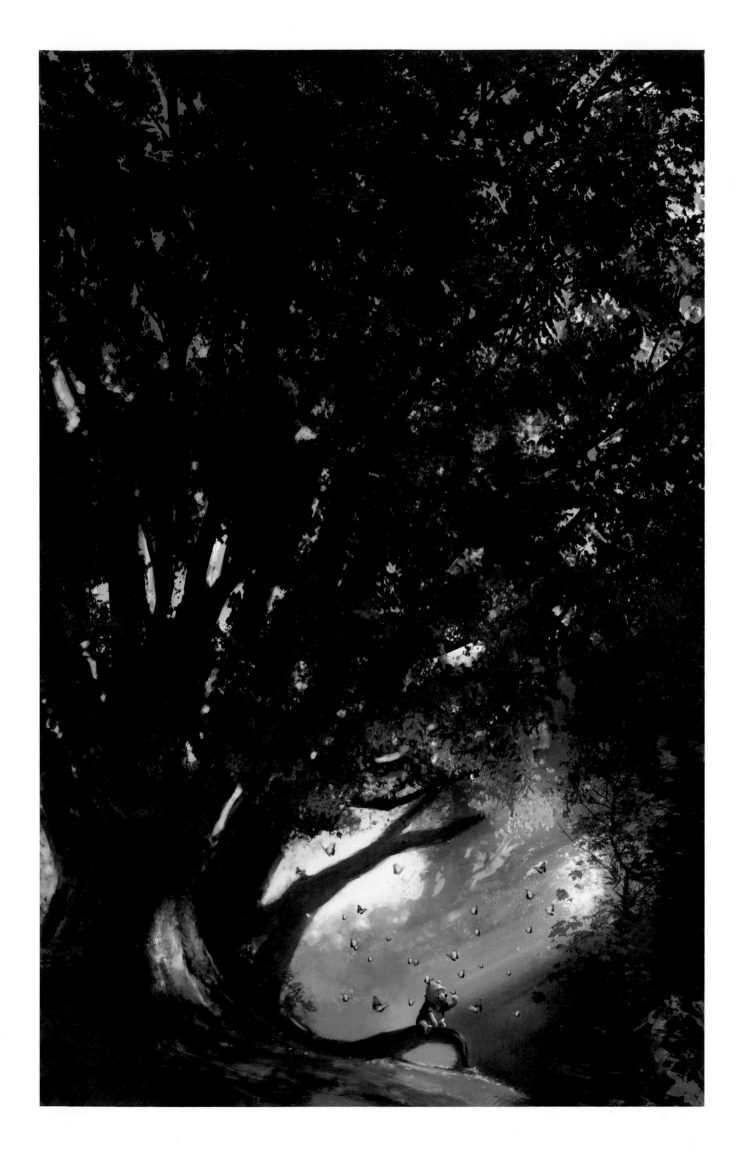

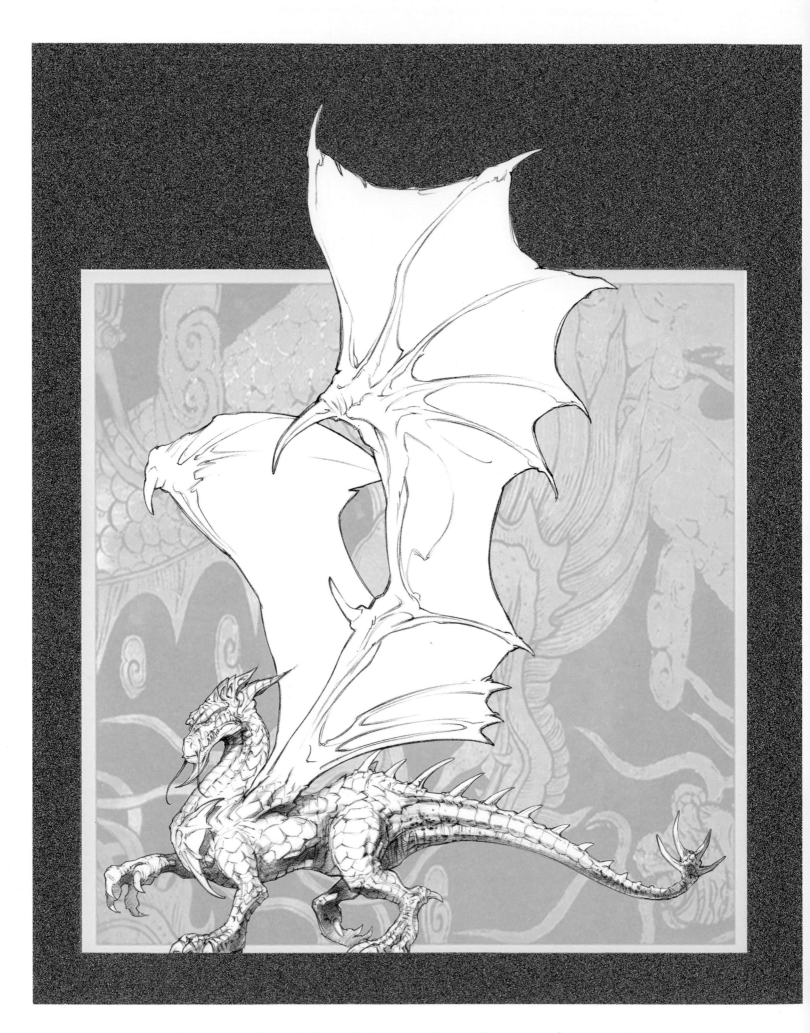

(Previous) *Do You Make Honey, Too?* Limited-edition giclée on canvas for Acme Archives.
(Above) Chinese Dragon concepts for *Dragonheart 2*

MARTINIERE
TRAJECTORY

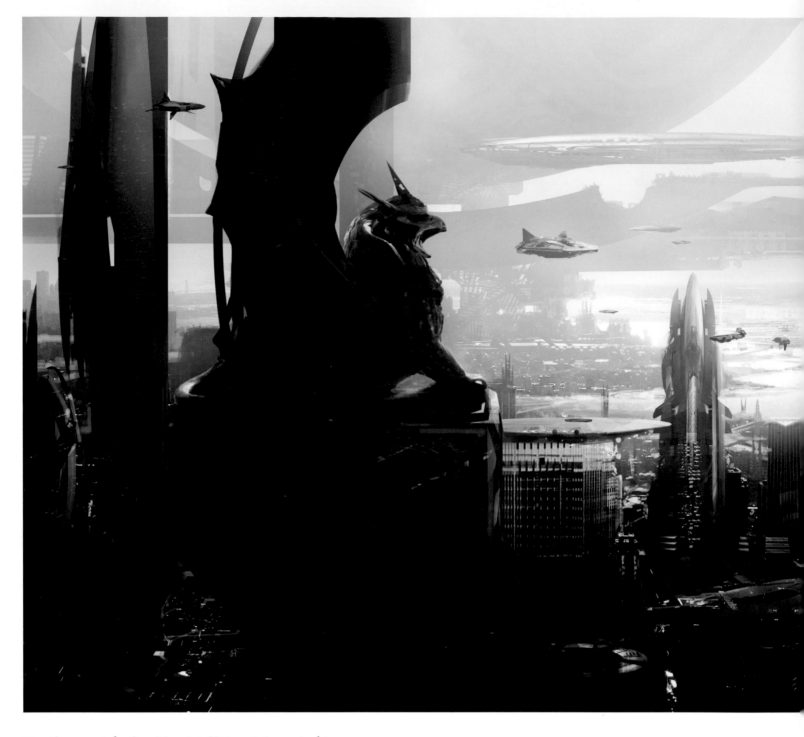

New Coruscant, for *Star Wars Art: Visions* © Acme Archives

Printed in China

First edition, July 2013

Hardcover ISBN 13: 978-162465002-4

Library of Congress Control Number: 2013935811

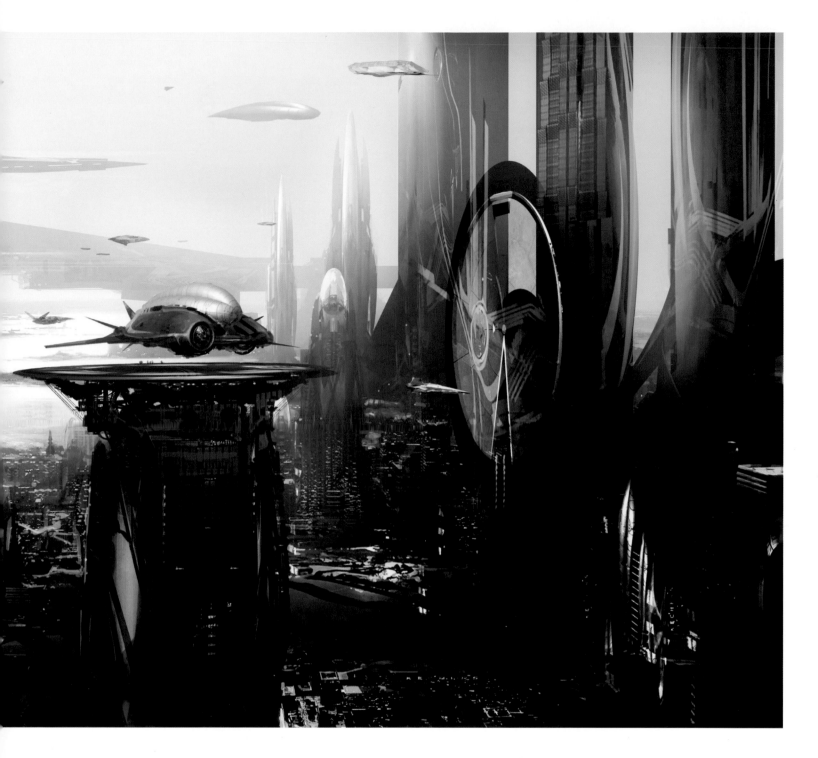

TABLE OF CONTENTS

FOREWORD

Is it possible to be someone's friend and still be his or her biggest fan? I think so. It's been my privilege to have known and worked with Stephan Martiniere for over a decade. For most of that period, I have served as his art director across some 21 book covers. Each has been a journey full of awe and wonder into lands beyond my imagination.

It is hard to capture in words what is ephemeral and numinous. When I think of Stephan's work—and I mean any of his work, not just his book covers but also his concept art for film, his work in comics and animation, his work designing playgrounds and theme parks—the word that comes to mind is not first and foremost "darkness" but "magnificence." This is followed by "exuberance," then "awe." While I may admire the realms on display from lesser illustrators, I want to participate in Stephan's imagination.

These days I am inundated with portfolios, and it is not unusual, particularly among the ranks of concept artists, to meet his artistic children. So often I see promising work that I can't use, not because it isn't technically skillfully executed, but because it is derivative of my friend's work. And why would I hire the imitation when I work with the source? Especially when the source is still the vanguard.

Stephan is a classically trained digital master, a painter with both brush and software, an artist and a designer, with a broad base of experience across multiple arenas. Perhaps this is why there is such concreteness, a tangible conviction to his work. He does not merely show us the fantastical and the impossible; he invites us to live there. His cityscapes, his environments, his space scenes, his fantastical or futuristic buildings are all places that I want to see made real. Even his darker visions have me wanting to inquire about real estate and freight for my furniture. I want to walk among those streets and gaze up or down in wonder at the towering edifices. I want to believe that these places exist, if not on our earth, then on some world somewhere.

Illustrators are the vital first connection with the world for any work of literary imagination. The common wisdom is that you have about five seconds or less to catch the eyes of someone walking past book covers and make them pause. If you can hold their attention for 30 seconds, you can close the deal. What is needed is a cover that can draw attention and invite you in, that does not merely render the contents of the book accurately but also issues an invitation to explore. A cover should tantalize, challenge and offer, pulling the viewer into the pages within. Without that lure, no matter how skillful or compelling the prose inside, the story will not reach its intended audience.

It is a privilege and an honor to have collaborated so often and for so long with such a magnificent visionary. He has as much diversity in his future as he has breadth of experience in his past. Stephan is always pushing himself, always moving to the next horizon. Each new piece that I receive from him pushes the boundaries of his own considerable talent just a little bit further. And isn't that the definition of a true artist?

It's been an exciting journey this past decade-plus. I can't wait to see where the next decade takes us. And for you coming to his work here, prepare to be drawn in, prepare to be transported to other worlds and other times, prepare to be mesmerized and captivated. Prepare yourself for awe.

Sincerely,

Lou Anders, Editorial and Art Director
Pyr, an imprint of Prometheus Books
www.louanders.com

INTRODUCTION

To my wonderful and talented daughter, Madelynn. There are never enough words to thank her for her constant support, dedication, hard work, and guidance. I am a lucky dad to have her by my side to help me stay focused and appreciative day after day.

To all my friends and fans who have followed, enjoyed, and supported my work all these years and made this artistic journey an incredible experience.

An artist's style is grown over a long period of time, and mine is no exception. I came from a background that was very comic-book-oriented. In France the comic-book styles were very eclectic, and there were new styles being introduced constantly, from the clean lines of Hergé, to the New Belgium School and the introduction of *Metal Hurlant* (*Heavy Metal*), which drastically changed graphical narration in the '70s. Because of that, my style came from many very strong influences, most notably Moebius, Bernie Wrightson, Enki Bilal, and Philippe Druillet.

At the same time that I was drawn to those more realistic artists, I was also very interested in the cartoon style. I was already exposed to Walt Disney and the world of animation, but I was also introduced to comics like *Spirou*, *Tintin*, and *Pif,* and artists such as Franquin, Uderzo and Wasterlain. I loved learning these styles because it allowed me to jump back and forth from cartoon to realistic regularly.

Because of both the realistic and the cartoon influences, I was armed with many different ways of approaching concepts for characters and environments when I began my career in animation. When I started working digitally in Photoshop and Painter I had the opportunity to explore myself as a painter rather than a designer or a line artist. I was very hesitant; it was not nearly as comfortable as drawing, which I had done for years. But as I slowly became more used to digital, I started bringing those influences into my painting process.

I don't think you ever lose your big influences. Rather, you find new and unusual ways to play with their styles alongside your own. The style that I've developed is still an ongoing process; I'm regularly discovering new techniques and themes to explore through new references that I find and artists that I meet.

This is my fourth book, and I still have so much work I can't wait to share. I hope *Trajectory* gives you a deeper insight into the breadth of my work, while juxtaposing my earlier pieces with some much newer ones for the sake of contrast and comparison. I hope you enjoy it.

Sincerely,

Stephan Martiniere
Concept Illustrator and Art Director

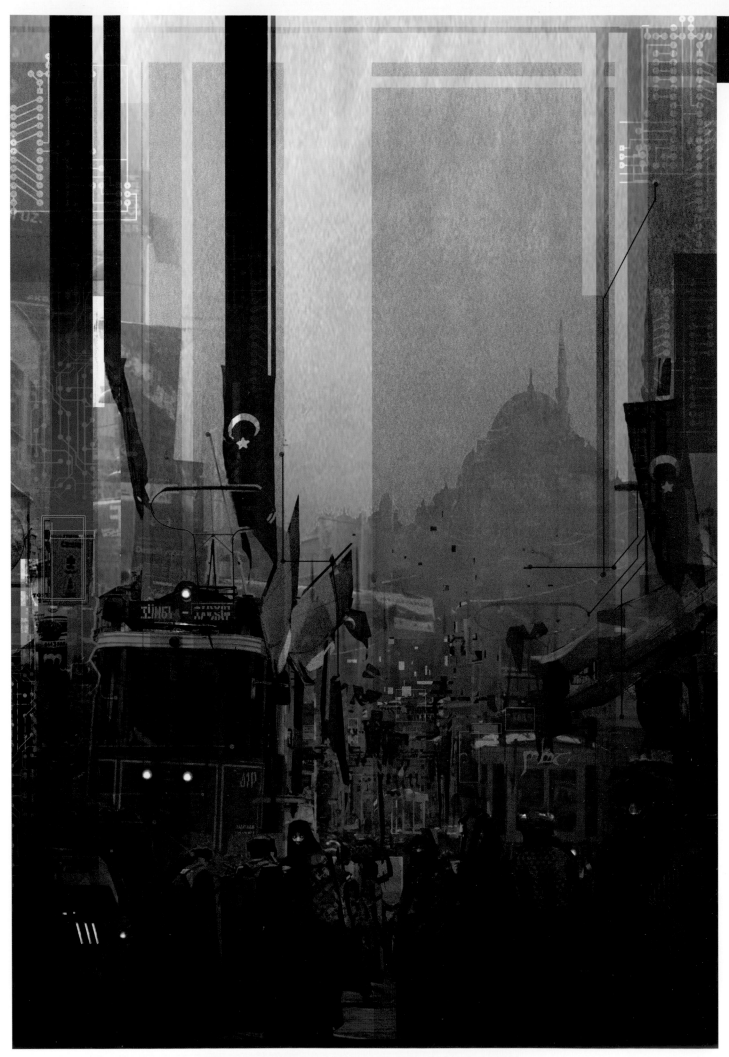

The Dervish House, Ian McDonald. Published by Pyr Books.

BOOKS

When I do a book cover, there are always two ways I can approach it: one is very detailed and literal, and the other is more abstract and figurative. How I choose one over the other is based primarily on the receptiveness of the art director, and the amount of symbols and imagery I can garner from the information provided.

Many of the book covers introduced in this section show my exploration of bolder, more vivid colors, as well as more graphic techniques. While I still have my ongoing process of creating more painterly pieces, I try more and more to break out of my comfort zone to try new palettes and techniques that I would not be able to explore with concept work for film or video games. When I look at paintings like *Dervish House* or *Omnitopia*, they demonstrate a much more graphic technique, which in turn lends itself to bolder colors.

Ultimately, the artistic process is all about finding those things that are equally challenging and rewarding. It's important not to get stuck on a particular style, and to continually renew yourself artistically. Challenging yourself with exploration is the springboard for a whole new host of surprises and opportunities.

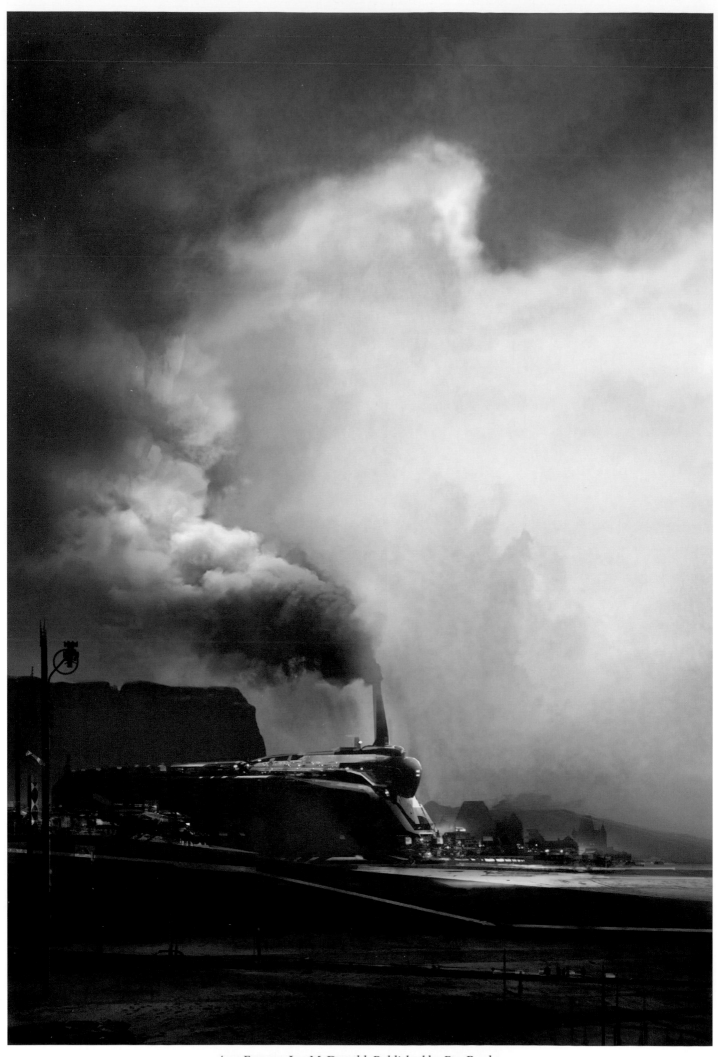

Ares Express, Ian McDonald. Published by Pyr Books.

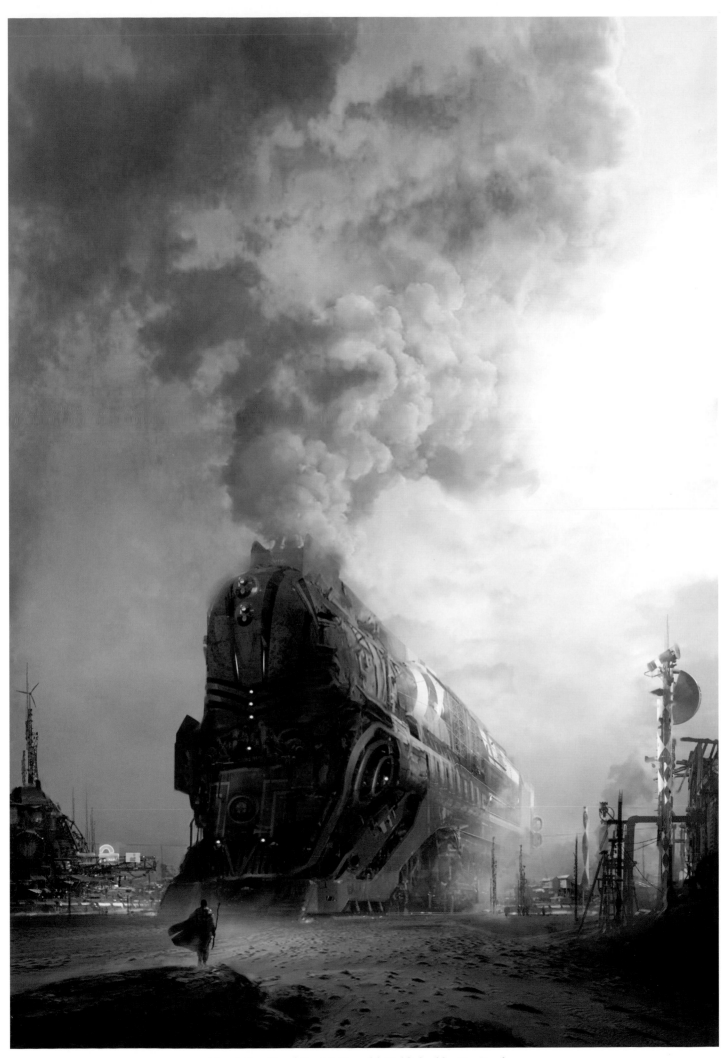

Desolation Road, Ian McDonald. Published by Pyr Books.

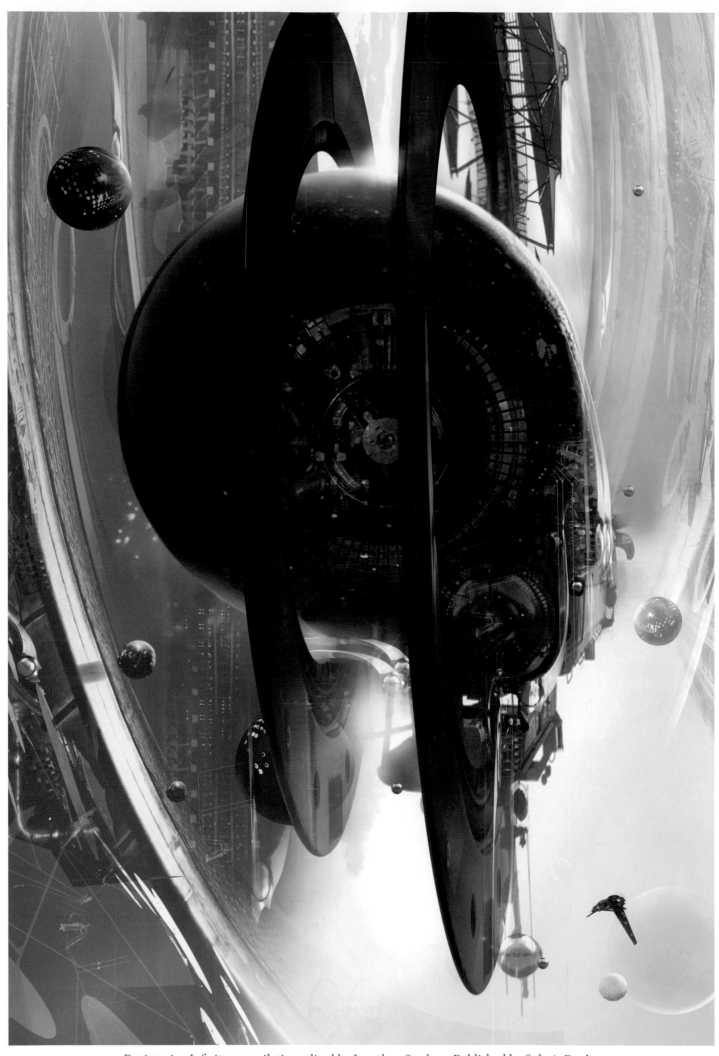

Engineering Infinity, compilation edited by Jonathan Strahan. Published by Solaris Books.

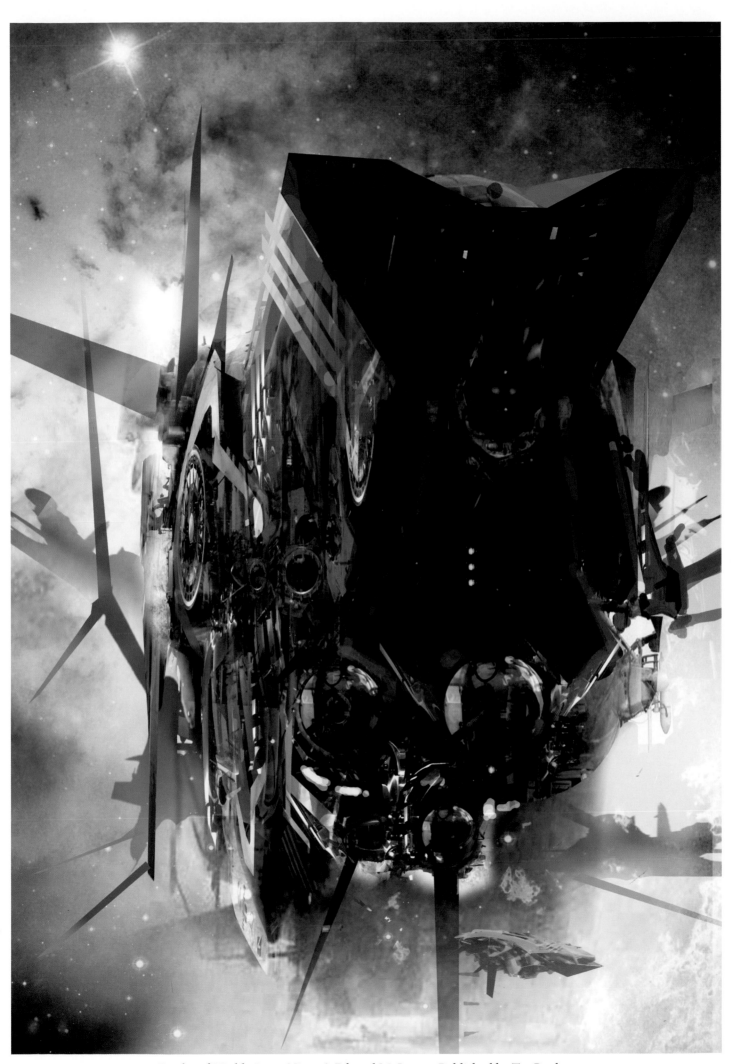

Juggler of Worlds, Larry Niven & Edward M. Lerner. Published by Tor Books.

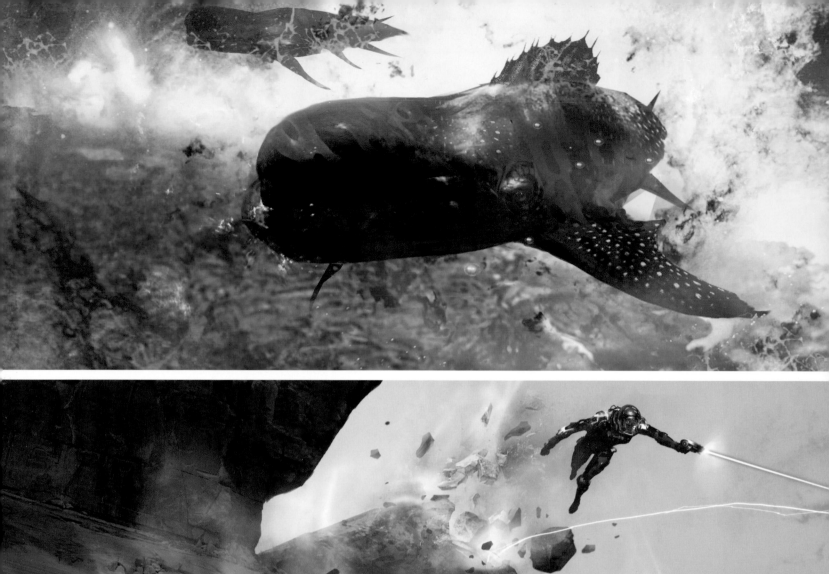

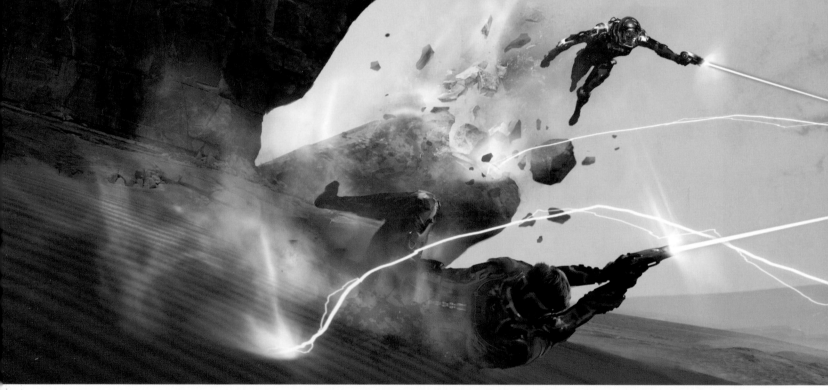

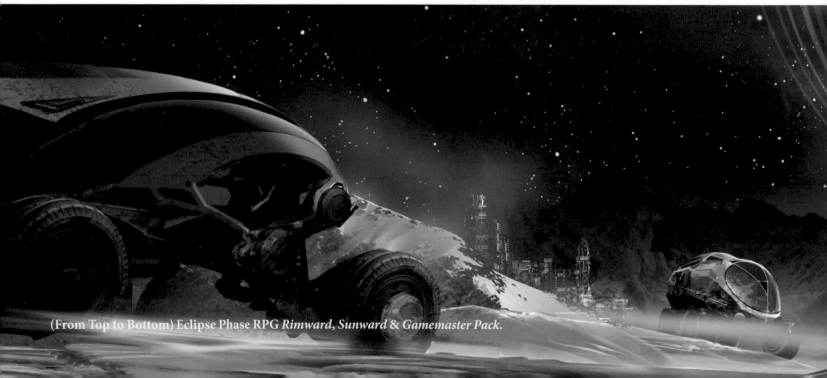

(From Top to Bottom) Eclipse Phase RPG *Rimward*, *Sunward* & *Gamemaster Pack*.

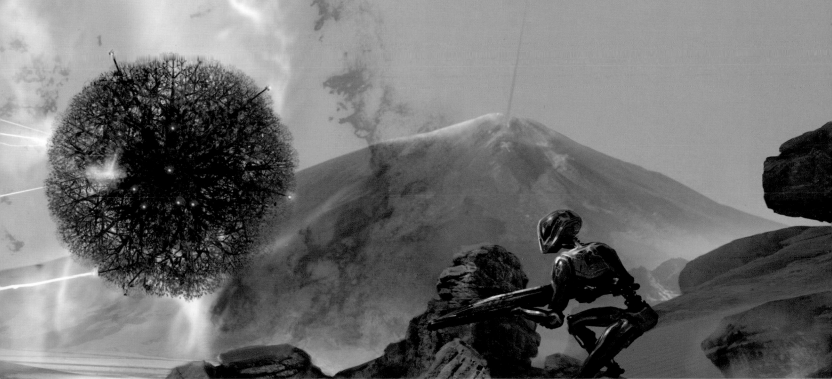

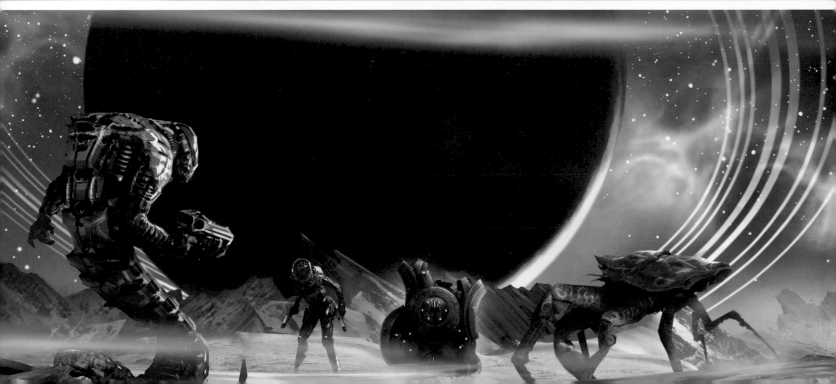

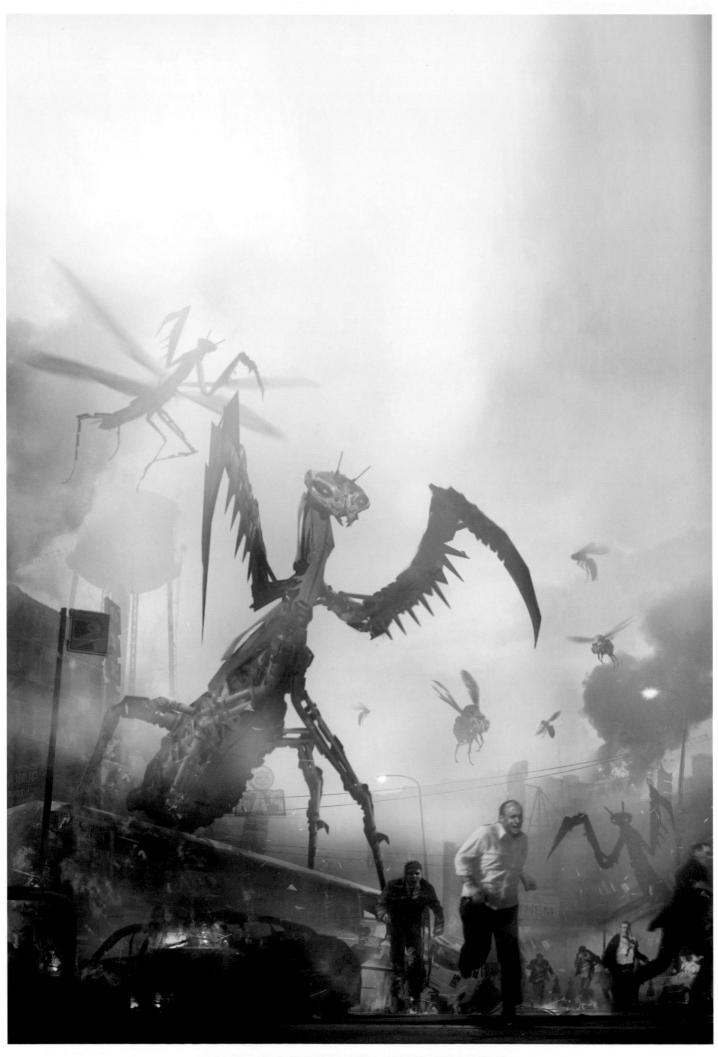

Assault on Sunrise, Michael Shea. Published by Tor Books.

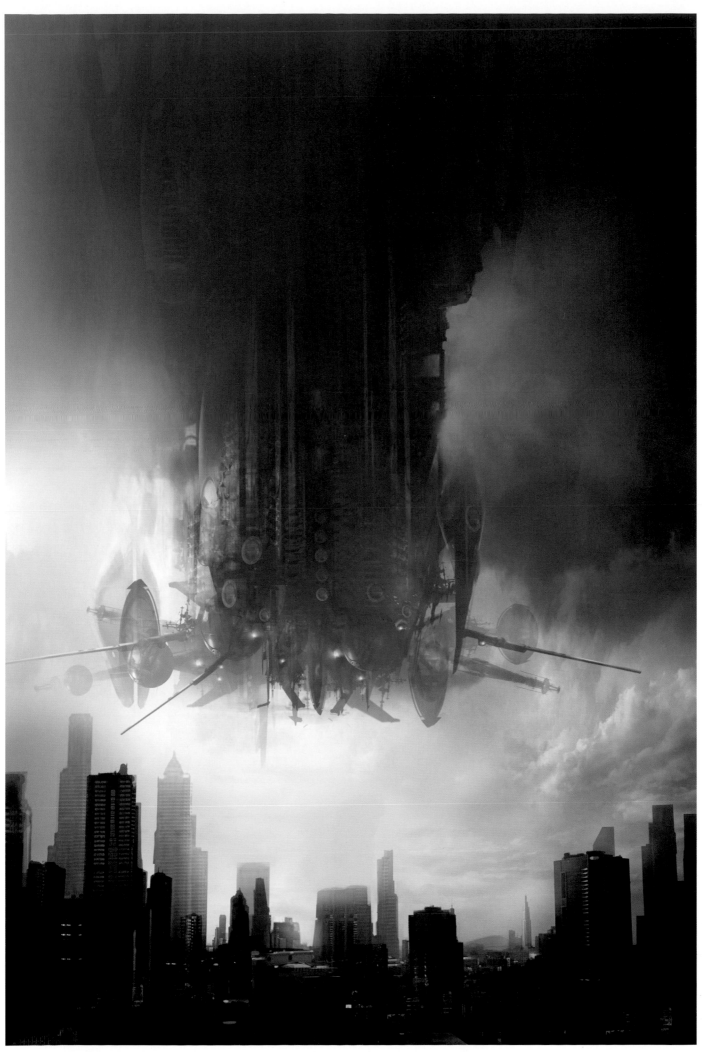

Out of the Dark, David Weber. Published by Tor Books.

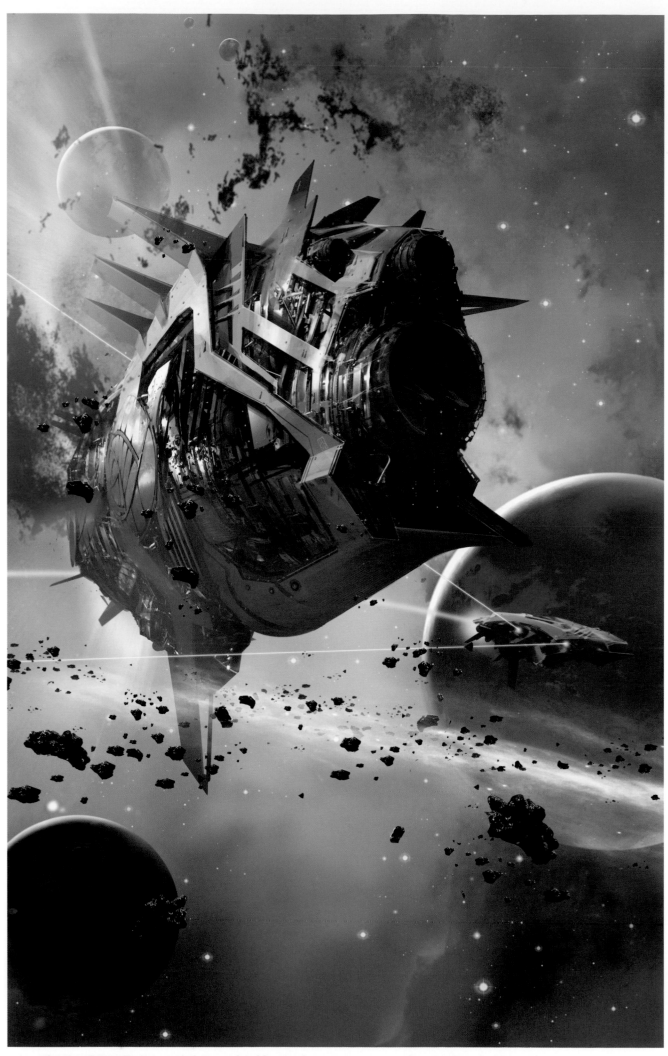

The New Space Opera, compilation edited by Gardner Dozois & Jonathan Strahan. Published by HarperCollins.

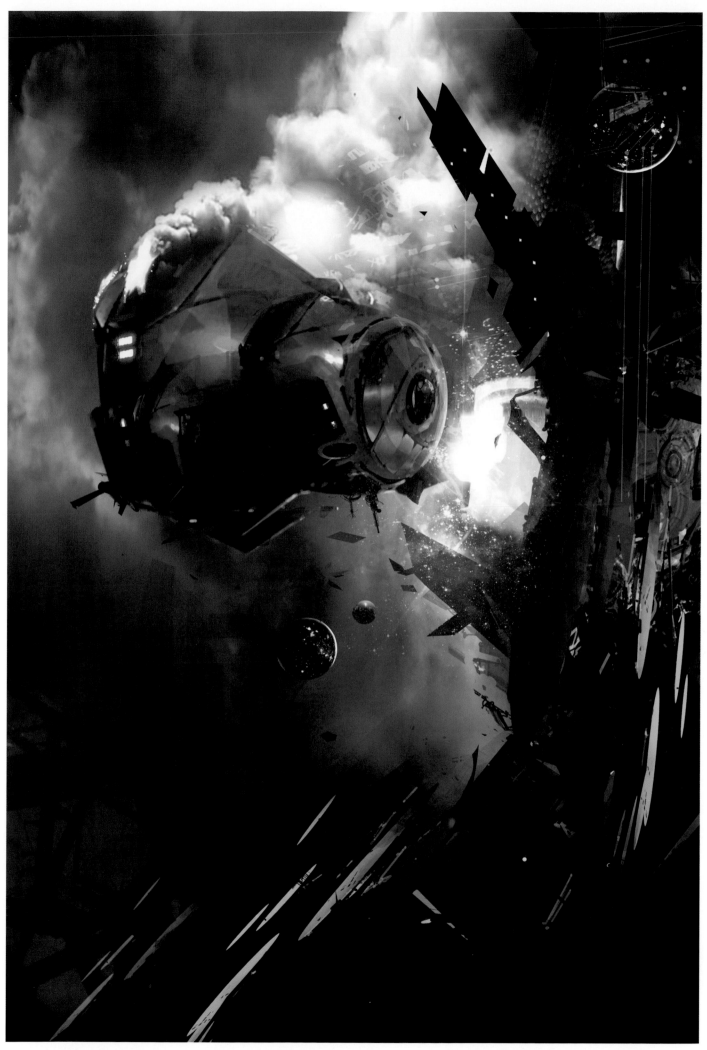

The New Space Opera 2, compilation edited by Gardner Dozois & Jonathan Strahan. Published by HarperCollins.

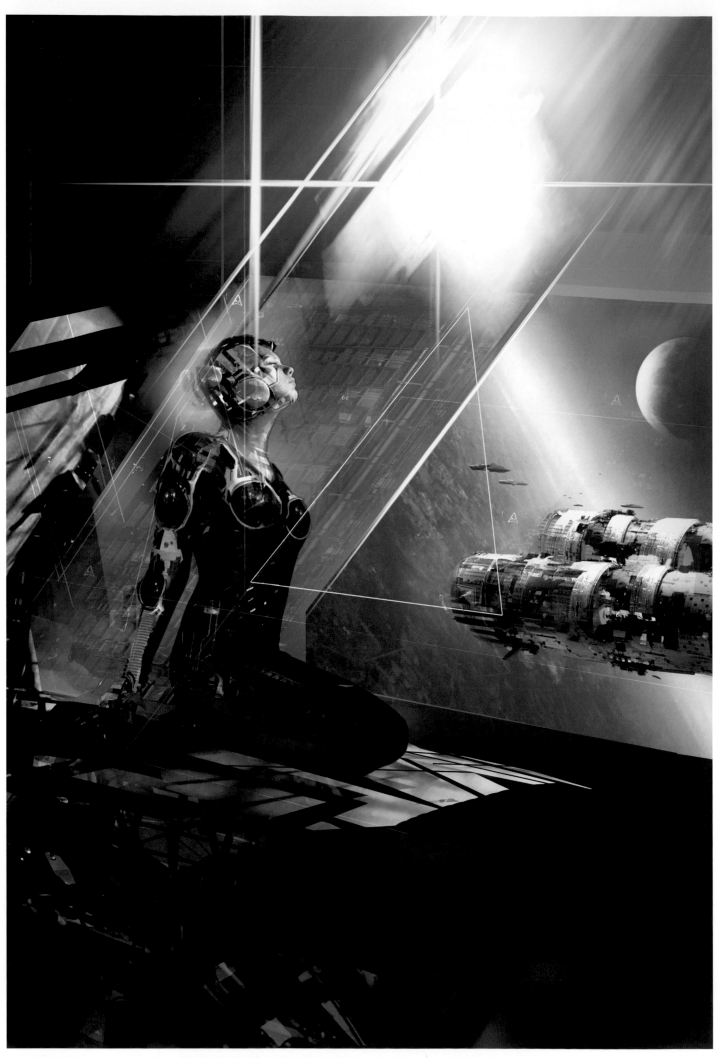

The Burning Skies, David J. Williams. Published by Random House.

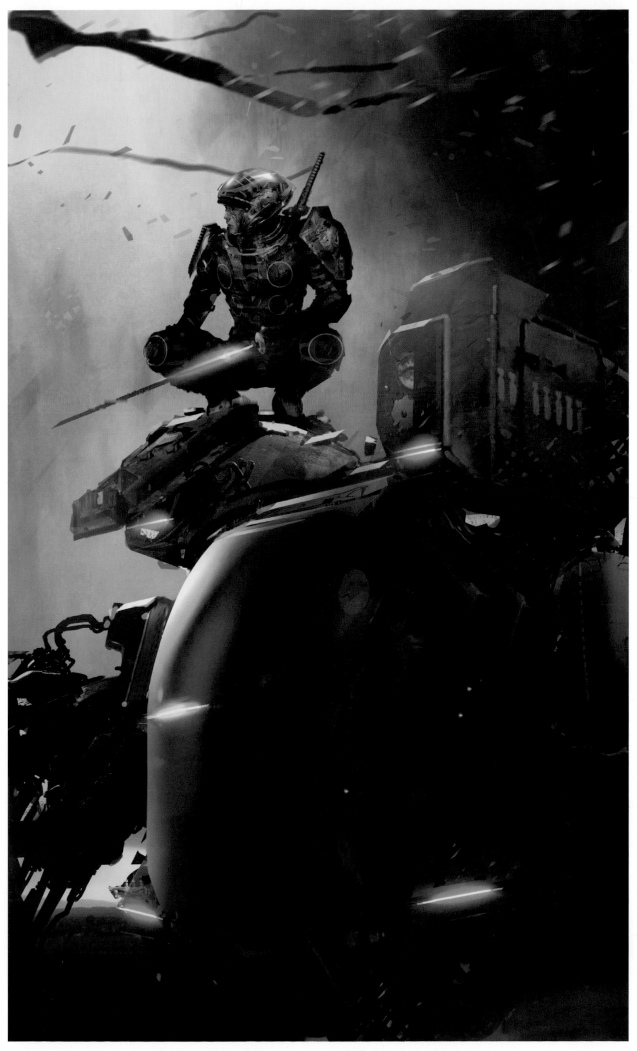

Shrapnel: Hubris Issue #1 Cover. Published by Radical Comics.

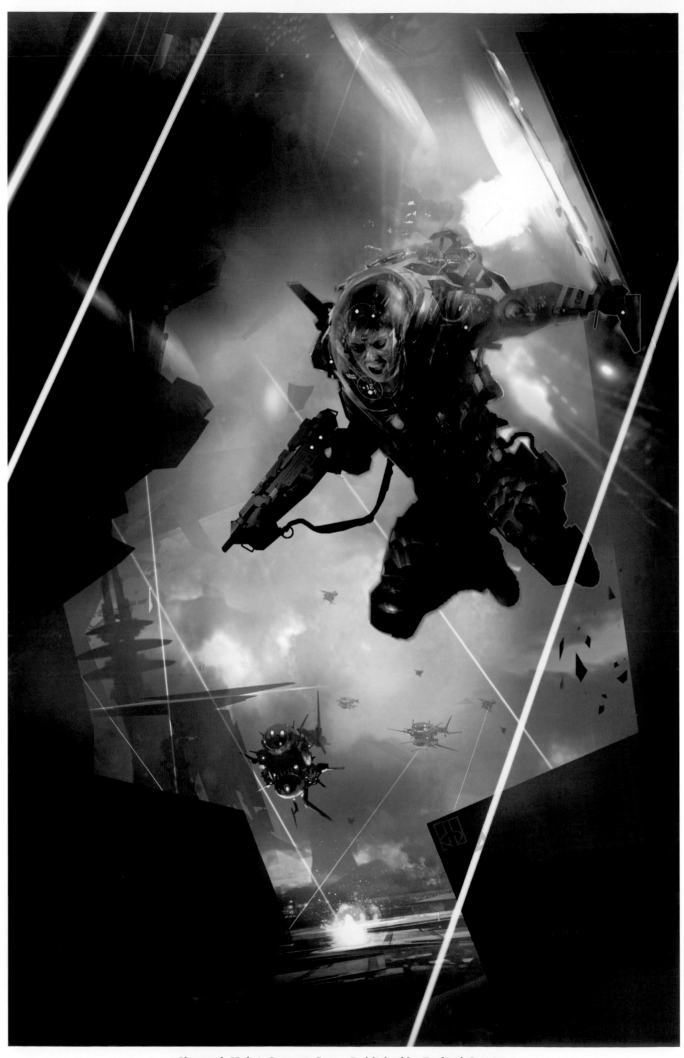

Shrapnel: Hubris Issue #2 Cover. Published by Radical Comics.

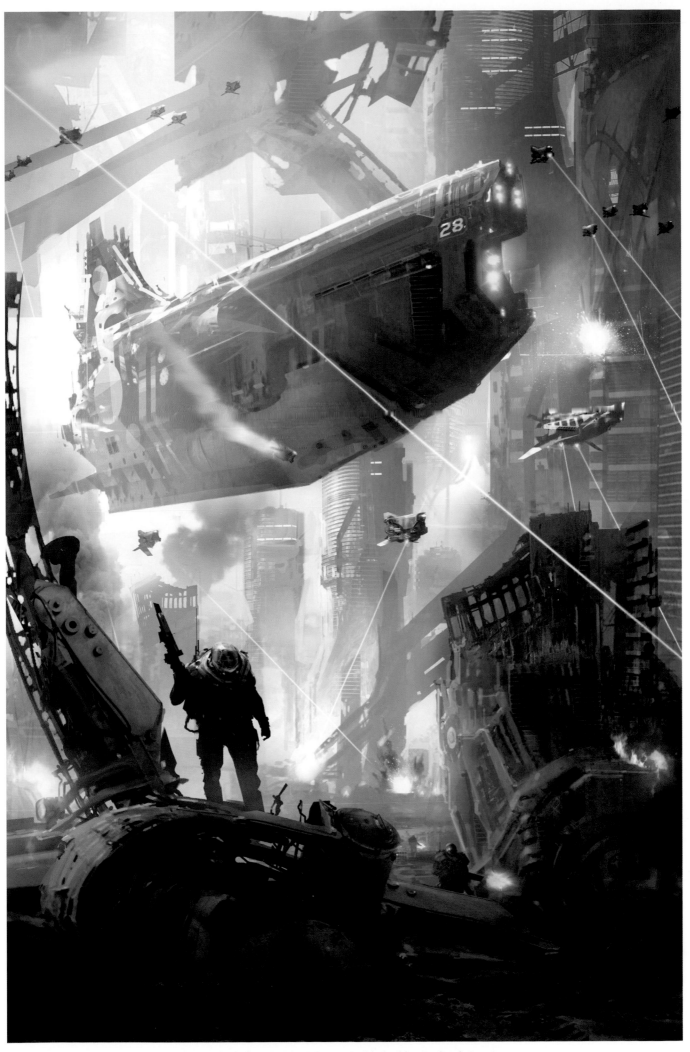

Shrapnel: Hubris Issue #3 Cover. Published by Radical Comics.

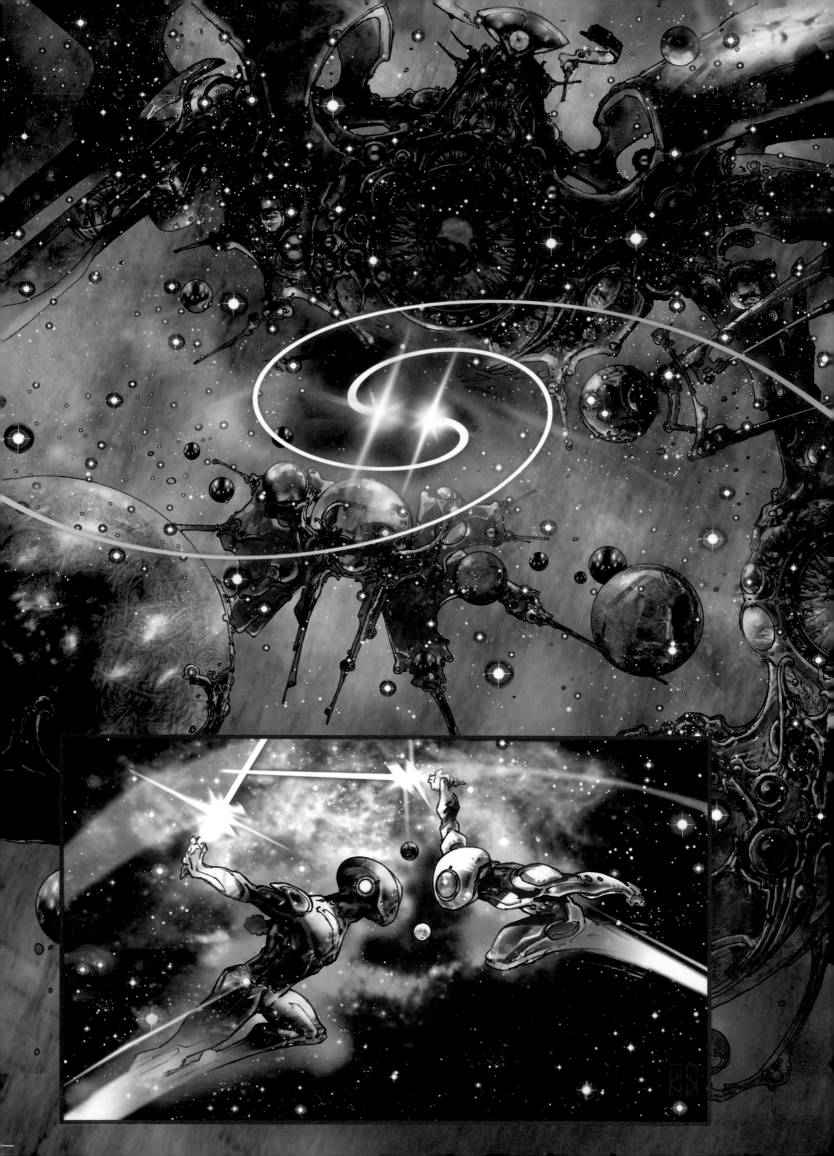

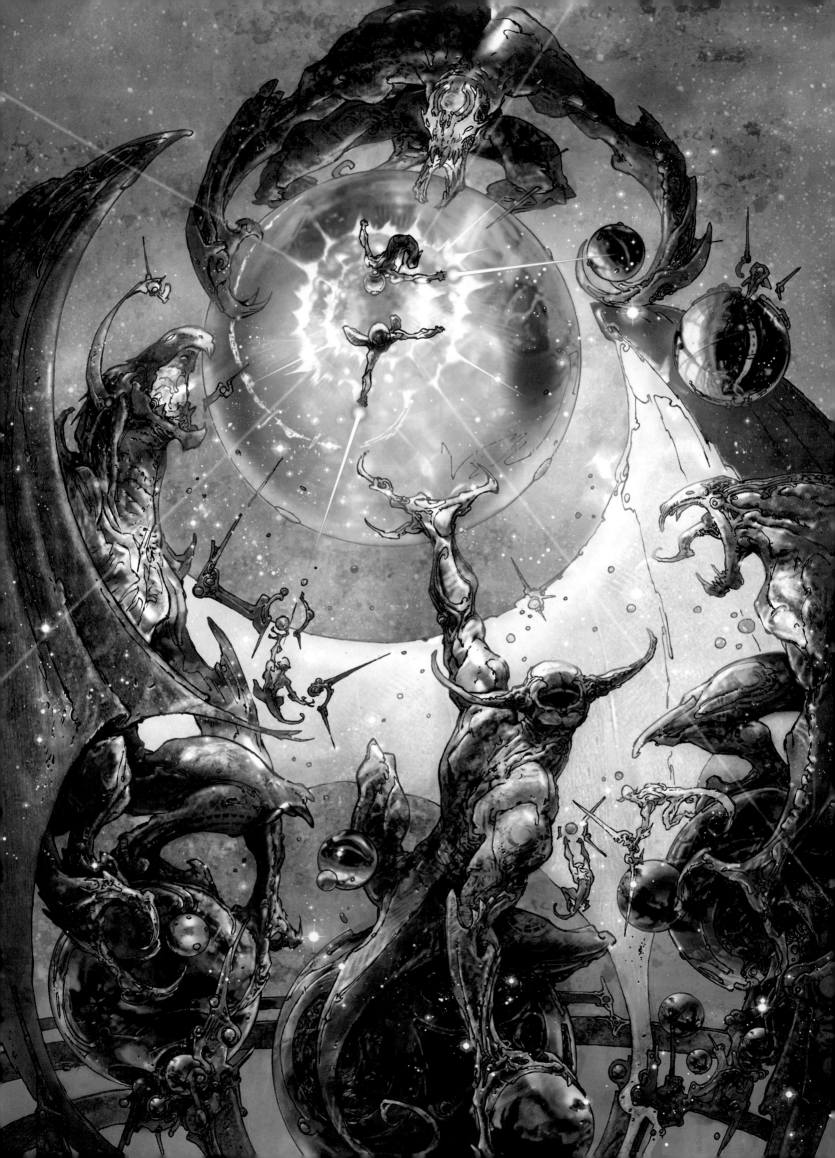

My professional roots are in animation, as I started doing book covers and concept art much later in my career. Despite the fact that I don't do as much animation anymore, I am very aware of how much my time in animation, early in my career, affected my development as an artist. After 20 years of working in other aspects of the industry, I've been thinking more and more about my time in animation, and how much I long for an opportunity to do it again. While I've always enjoyed being able to do both cartoon and realistic work, there's a certain freedom of expression in doing cartoons that's not necessarily present when you're doing something realistic. When I'm doing book covers or concept art, the goal is always to try to set up a world and a mood, while in cartoons it's all about making people laugh and smile.

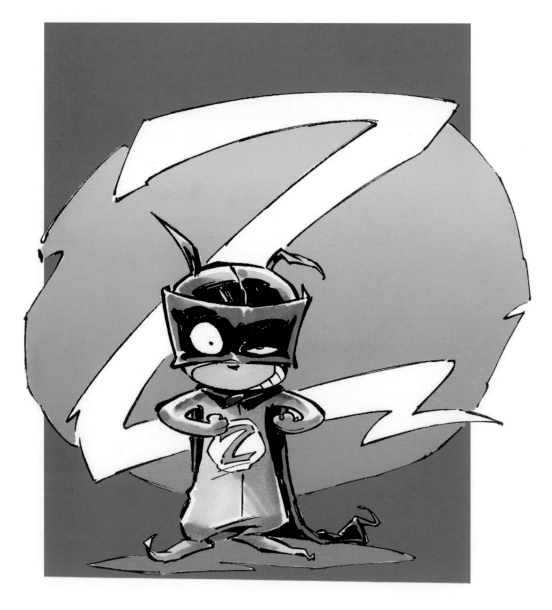

(Previous) Two pages from the *Star Wars: Visionaries* graphic novel
(Above) *Zap* character concept for *Zap!* animated TV series

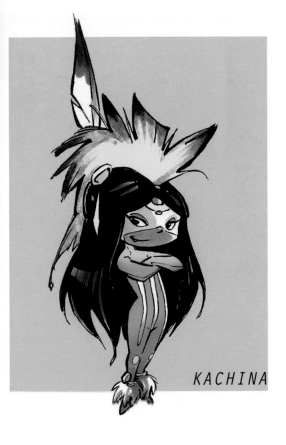

KACHINA

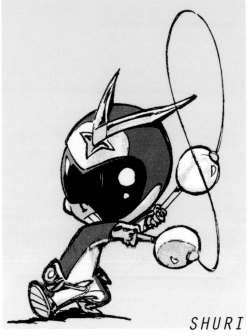

SHURI

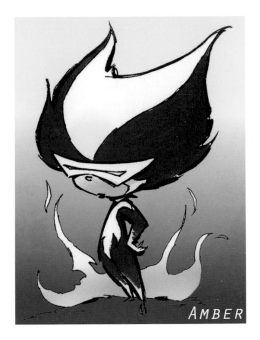

AMBER

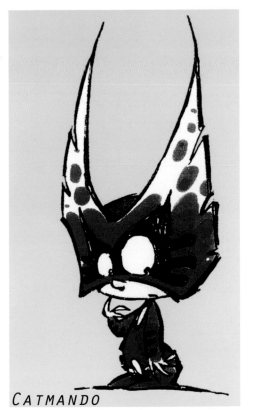

CATMANDO

Various character concepts for *Zap!* animated TV series

MS. BROOMBASHER

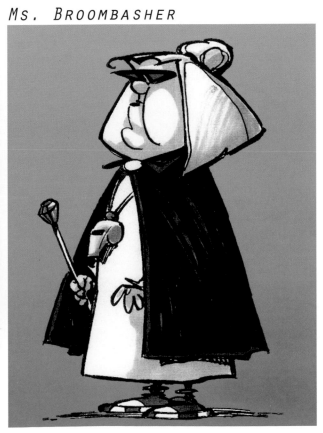

BABY BLAZE

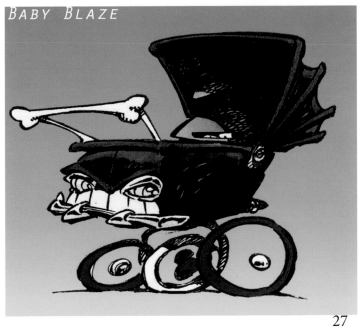

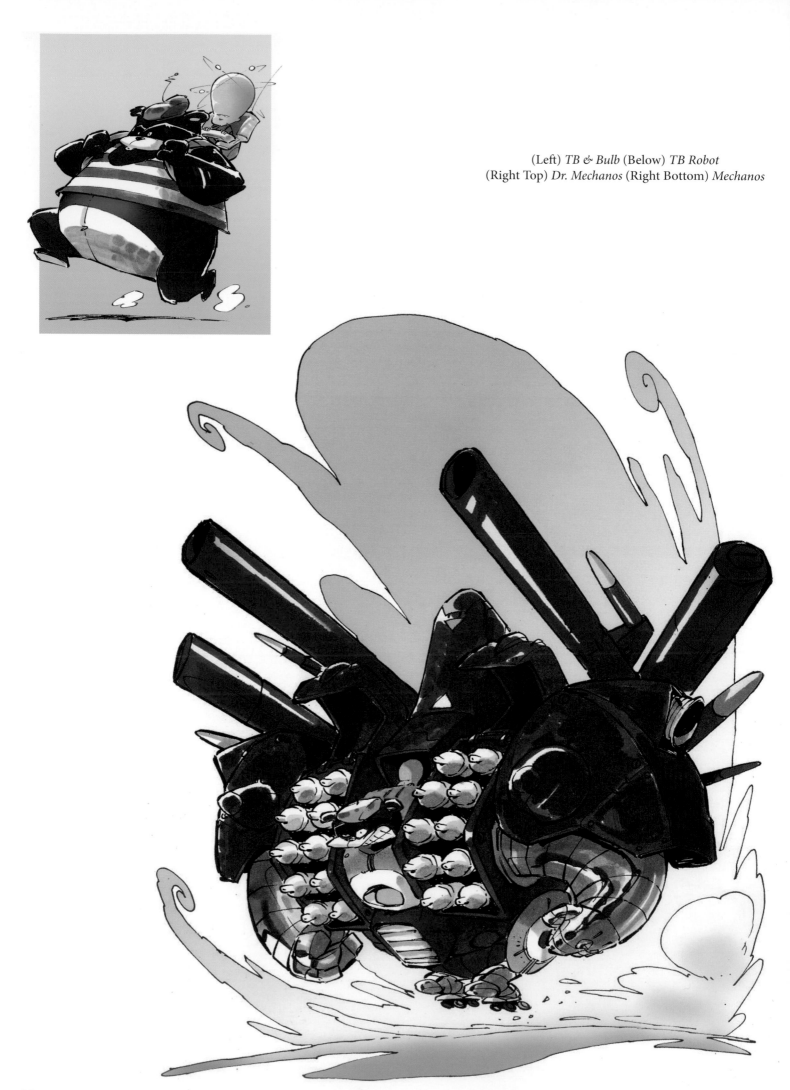

(Left) *TB & Bulb* (Below) *TB Robot*
(Right Top) *Dr. Mechanos* (Right Bottom) *Mechanos*

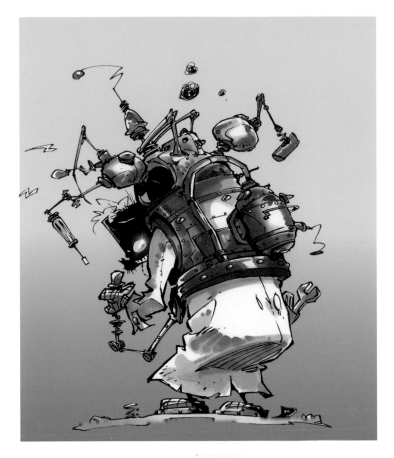

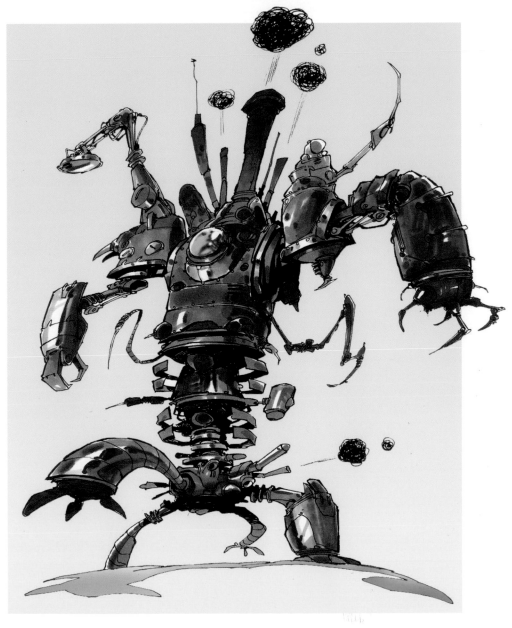

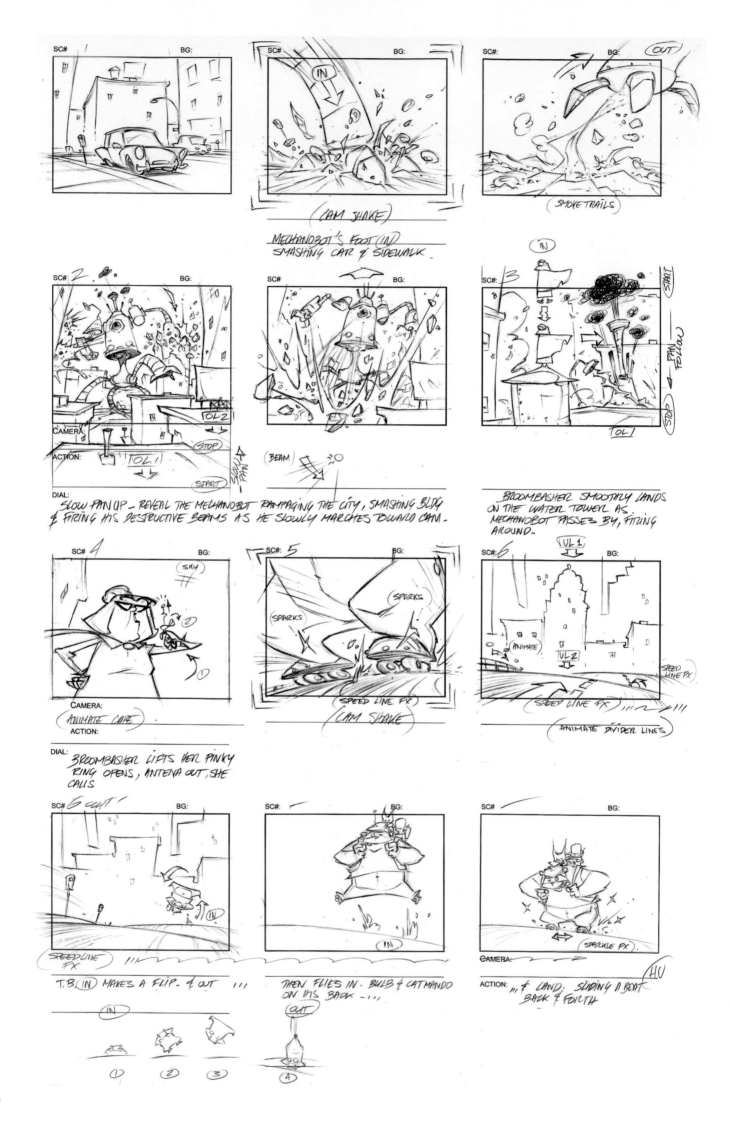

SC# 1 BG:

SC# 1 BG: (IN)
(CAM SHAKE)

SC# BG: (OUT)
(SMOKE TRAILS)

MECHANOBOT'S FOOT IN SMASHING CAR & SIDEWALK.

SC# 2 BG:
CAMERA: (STOP)
ACTION: (TOL 1) (START)

SC# BG:
(BEAM)

SC# 3 BG: (IN)
(TOL 1)

SLOW PAN UP - REVEAL THE MECHANOBOT RAMPAGING THE CITY, SMASHING BLDG & FIRING HIS DESTRUCTIVE BEAMS AS HE SLOWLY MARCHES TOWARD CAM.

BROOMBASHER SMOOTHLY LANDS ON THE WATER TOWER AS MECHANOBOT PASSES BY, FIRING AROUND.

SC# 4 BG: (SKY)
CAMERA: (ANIMATE CAPE)
ACTION:

SC# 5 BG:
(SPARKS) (SPARKS)
(SPEED LINE FX) (CAM SHAKE)

SC# 6 BG: UL 1
(ANIMATE) UL 2 SPEED LINE FX
(SPEED LINE FX) (ANIMATE DIVIDER LINES)

DIAL: BROOMBASHER LIFTS HER PINKY RING OPENS, ANTENA OUT, SHE CALLS

SC# 6 CONT BG:
(SPEEDLINE FX)
T.B. IN MAKES A FLIP- & OUT
(IN)

SC# BG:
(IN)
THEN FLIES IN. BULB & CATMANDO ON HIS BACK -
(OUT)

SC# BG:
CAMERA: (SPARKLE FX)
ACTION: & LAND: SLIDING A BEAT BACK & FORTH

① ② ③ ④

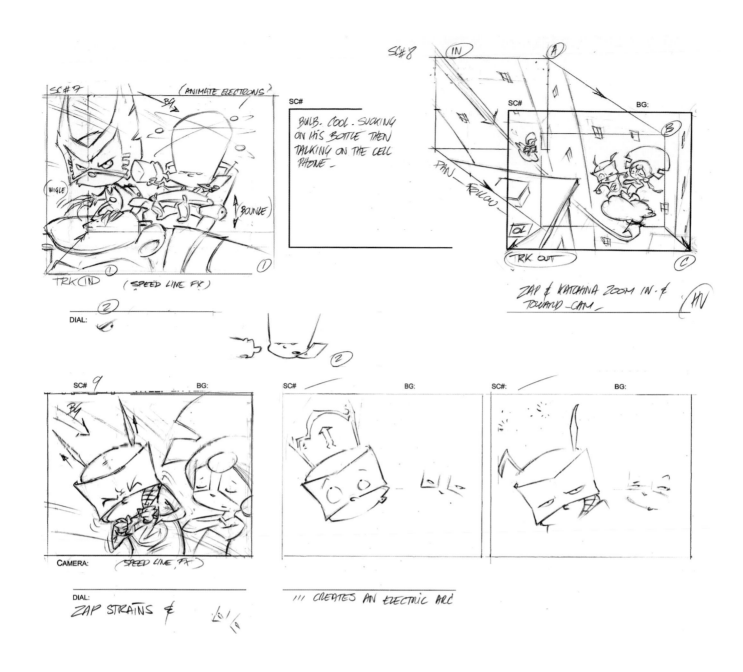

(Across and Above) Storyboards for *Zap!* Flash animation promotional trailer
(Below) *Zap!* comic strip

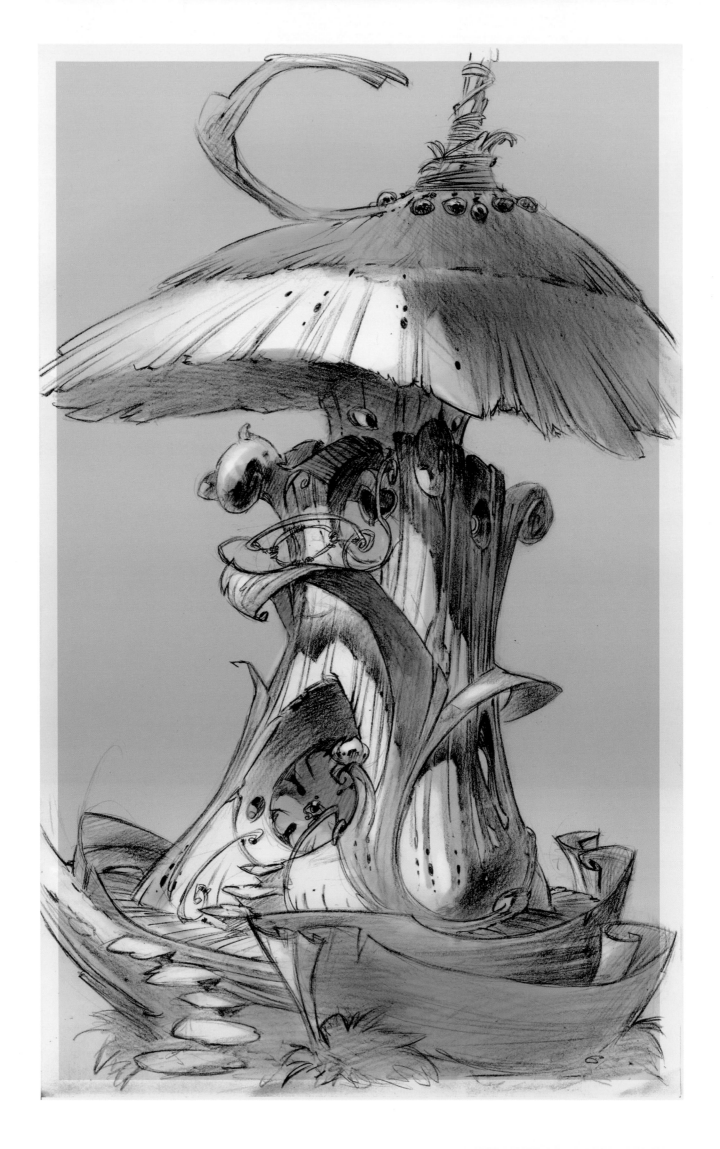

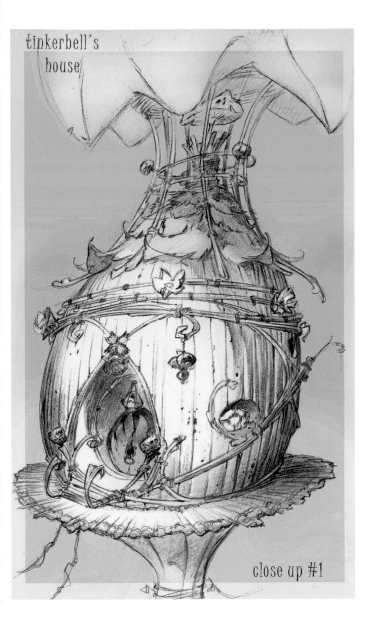

tinkerbell's house

close up #1

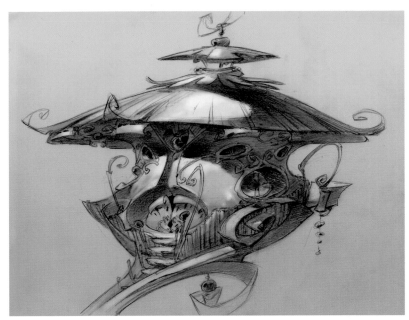

Concepts for *Tinkerbell* 3-D animated film, *House* and *Music Theatre*

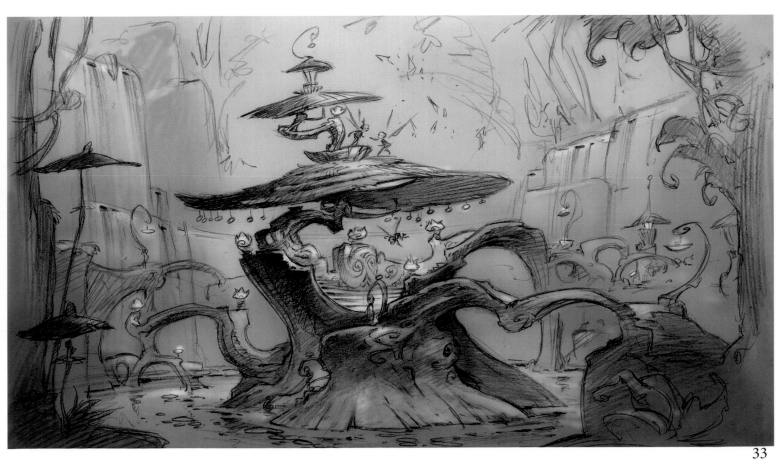

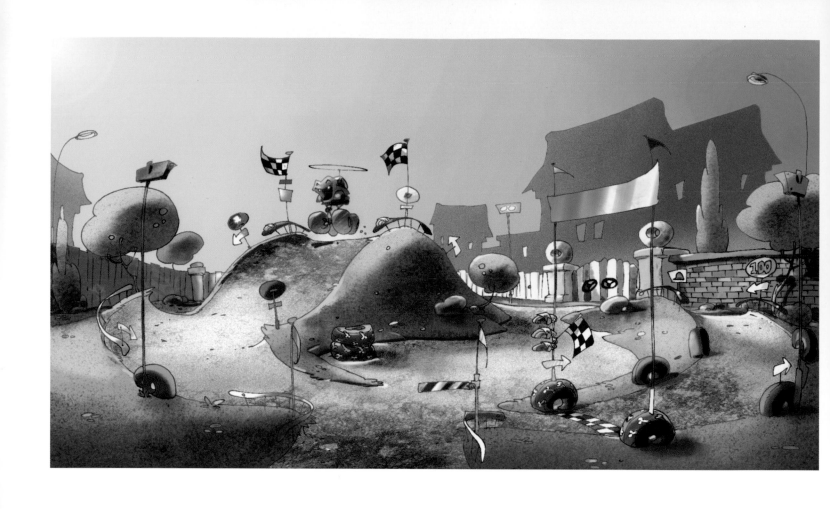

Concepts for *Monster Monster Trucks* animated pilot episode

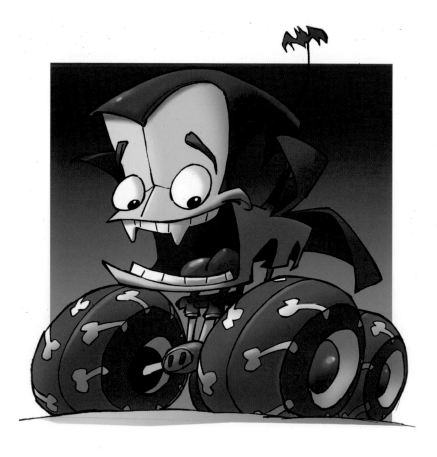

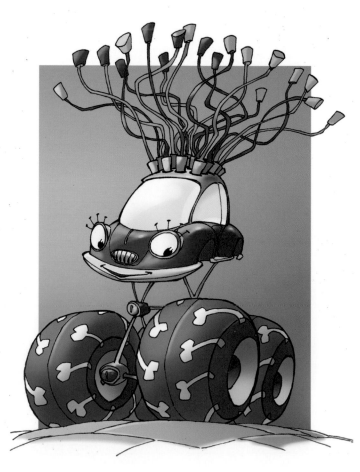

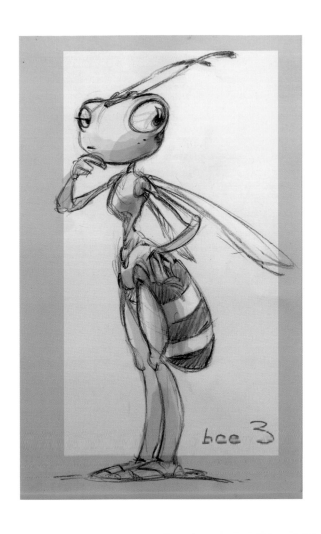
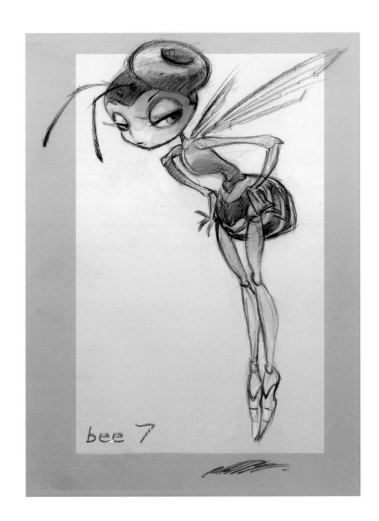

bee 3

bee 7

(Above) Cheerios concepts for bee character
(Below) *Joan of Arc*, independent project. Concepts for main character.

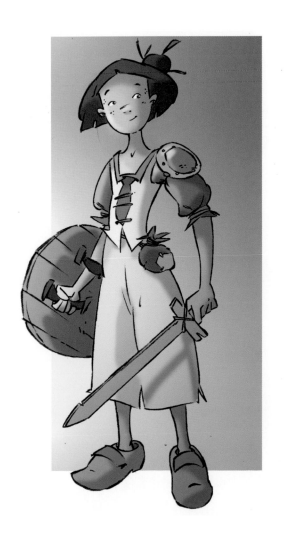
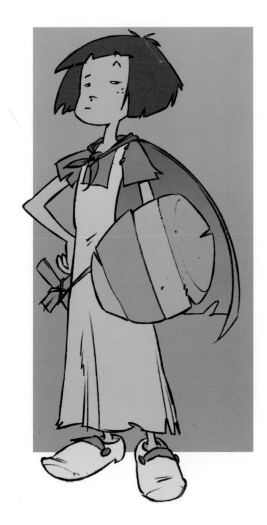

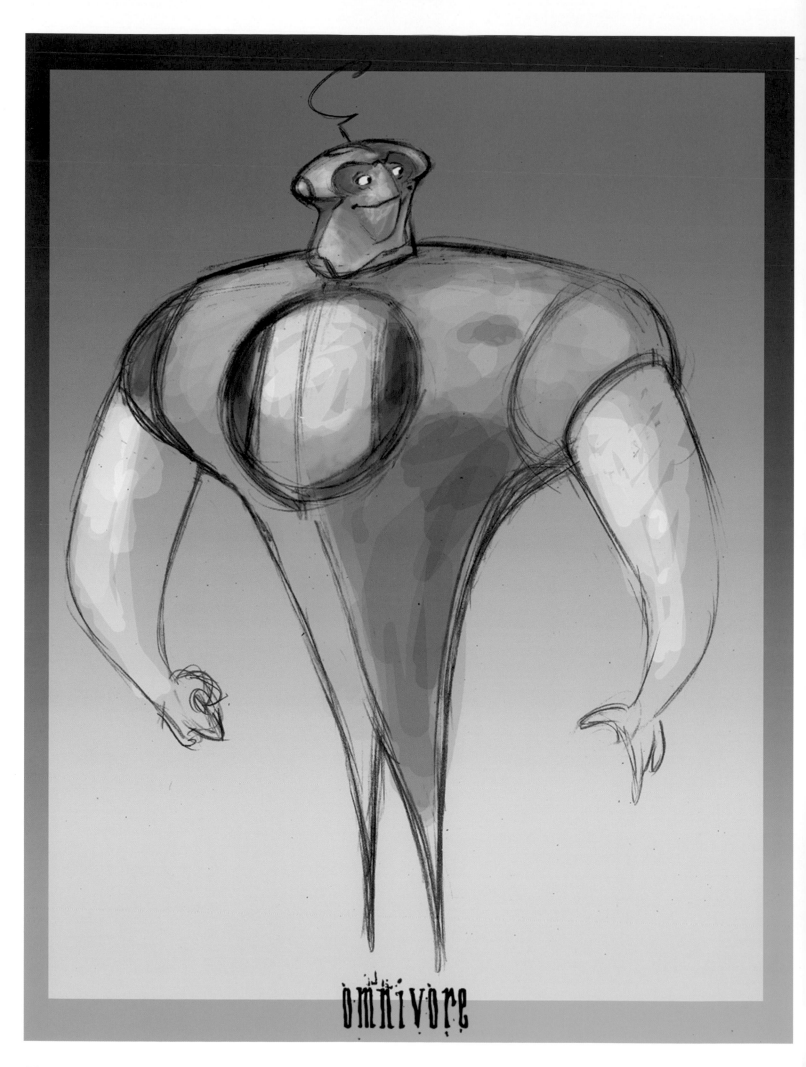

omnivore

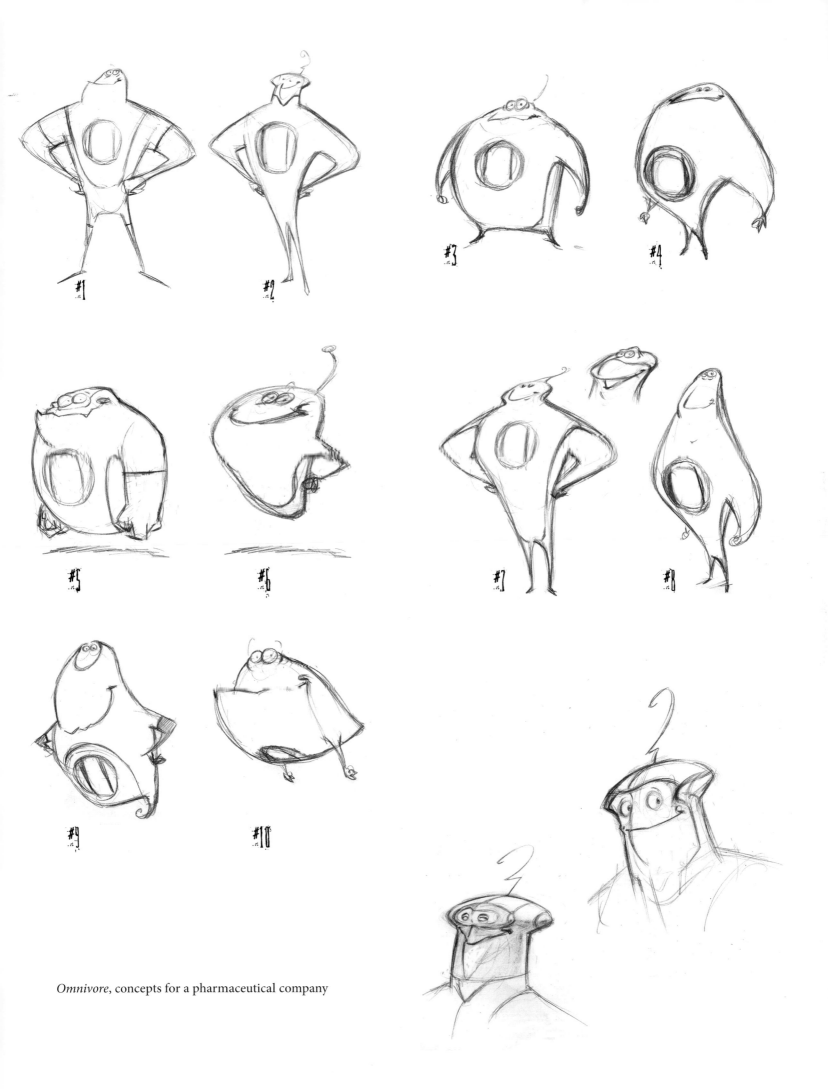

#1 #2 #3 #4

#5 #6 #7 #8

#9 #10

Omnivore, concepts for a pharmaceutical company

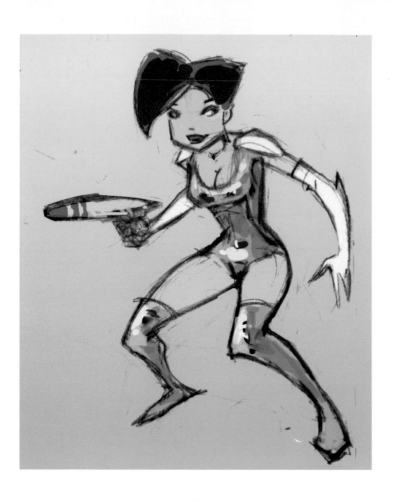

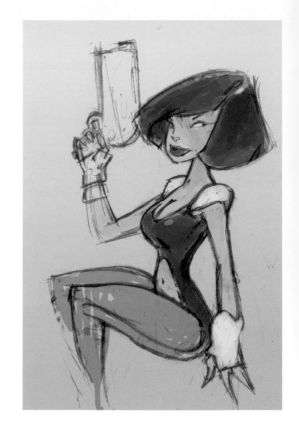

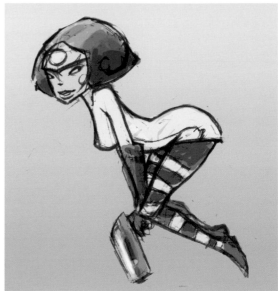

Various character concepts for the *Ruby* animated series based on
a radio show

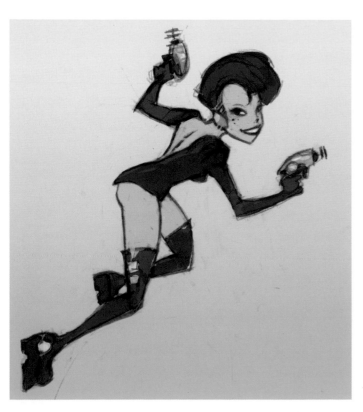

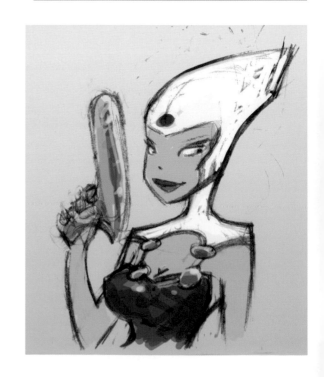

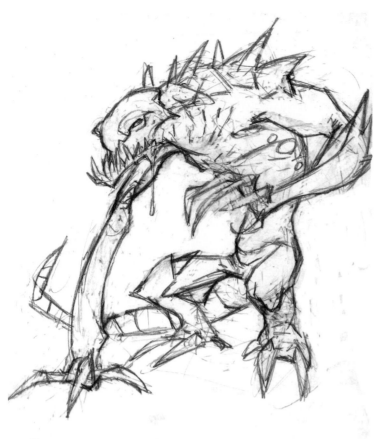

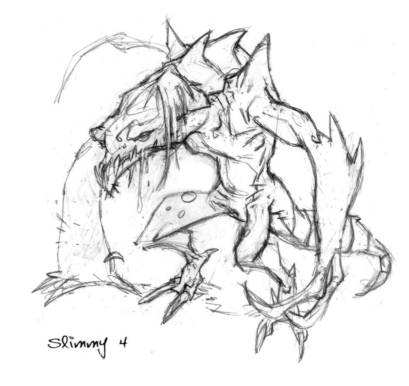

Slimmy 3

Slimmy 4

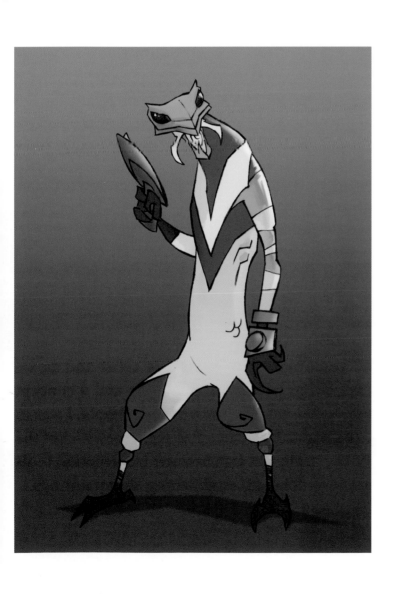

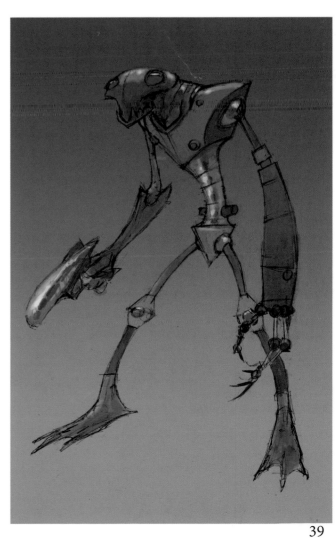

GAMES

The paintings presented in this chapter are works that I've done as both a concept artist and an art director for video games. The approach for a concept when I'm both an art director and a concept artist is slightly different than if I was just a concept artist. As the art director on *Stranglehold*, I was in contact with all the leads on the project on a daily basis, and had to be aware of all the necessities of the project. The images I created not only defined the style of the game, but also became information tools for all of the teams. Because of this, the pieces I did were very detailed, establishing shot paintings.

Hero preliminary concept

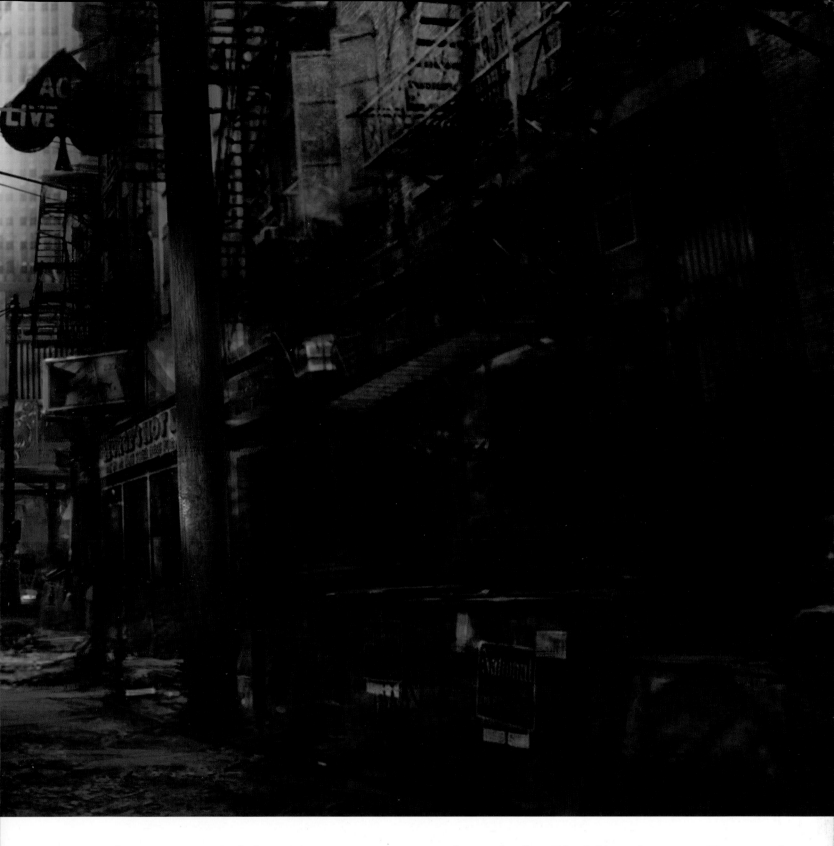

In contrast, the paintings I did as just a concept artist (namely for *BlackSite: Area 51*, *Hero*, and *Mortal Kombat vs. DC*) were not approached as deeply because I didn't have all the information the art director would have had. *Mortal Kombat vs. DC* was a much simpler arena-style game where all I had to do was define the look and feel of the main stage where the characters would be fighting. For *BlackSite: Area 51*, without knowing what exactly was going to be happening in each level, I could only define interesting concepts and moods.

Doing concept for games is both interesting and challenging because it's about finding solutions, creating visuals that become templates and tools to be used by an entire team. You become much more entrenched in the process than in film, aware of all the necessities and complexities of a project, and create art accordingly.

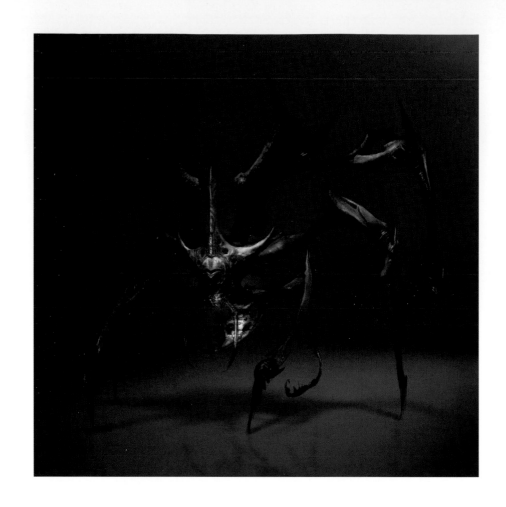

BlackSite: Area 51 Alien Spider

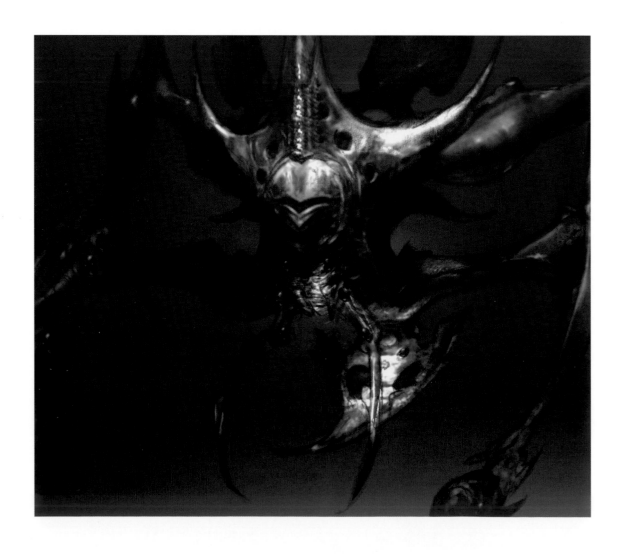

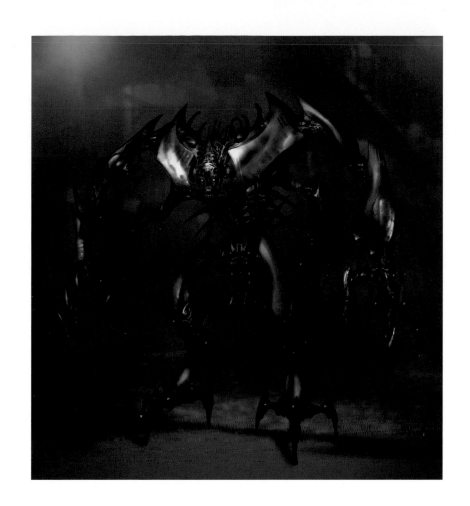

BlackSite: Area 51 Black Ops

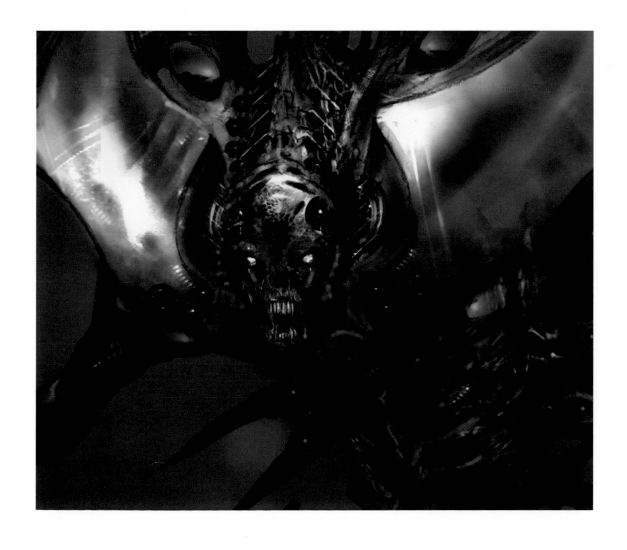

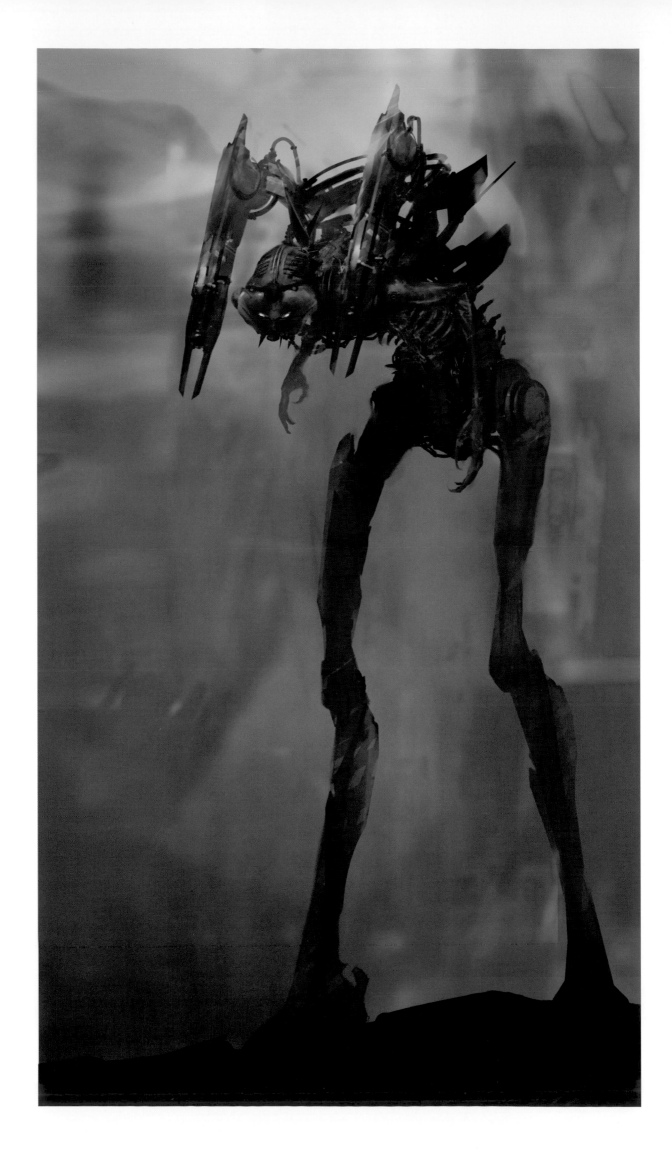

(Left) *BlackSite: Area 51* Reborn
(Right) *BlackSite: Area 51* Reborn armature
(Below) *BlackSite: Area 51* Reborn elevation

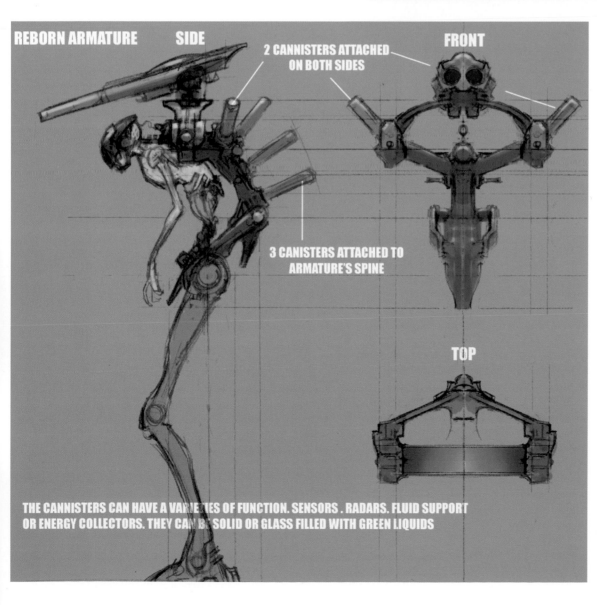

REBORN ARMATURE

SIDE

FRONT

2 CANNISTERS ATTACHED ON BOTH SIDES

3 CANISTERS ATTACHED TO ARMATURE'S SPINE

TOP

THE CANNISTERS CAN HAVE A VARIETIES OF FUNCTION. SENSORS . RADARS. FLUID SUPPORT OR ENERGY COLLECTORS. THEY CAN BE SOLID OR GLASS FILLED WITH GREEN LIQUIDS

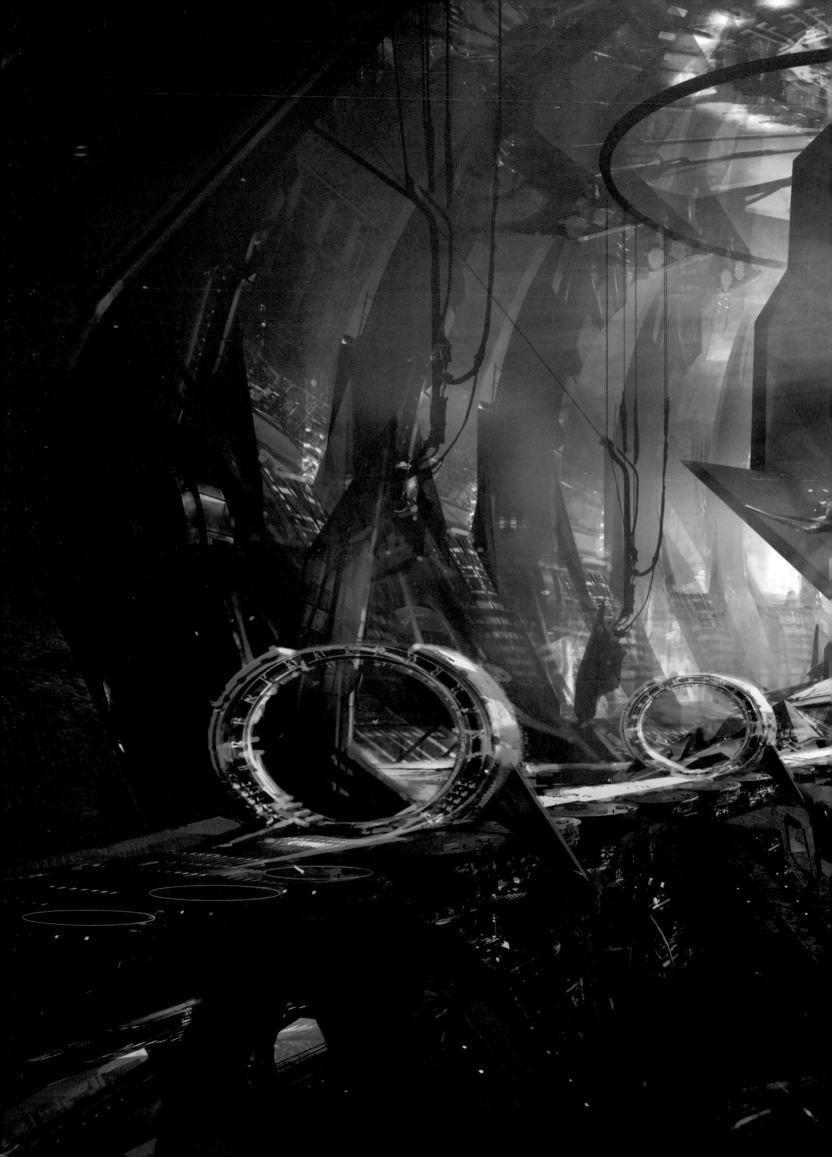

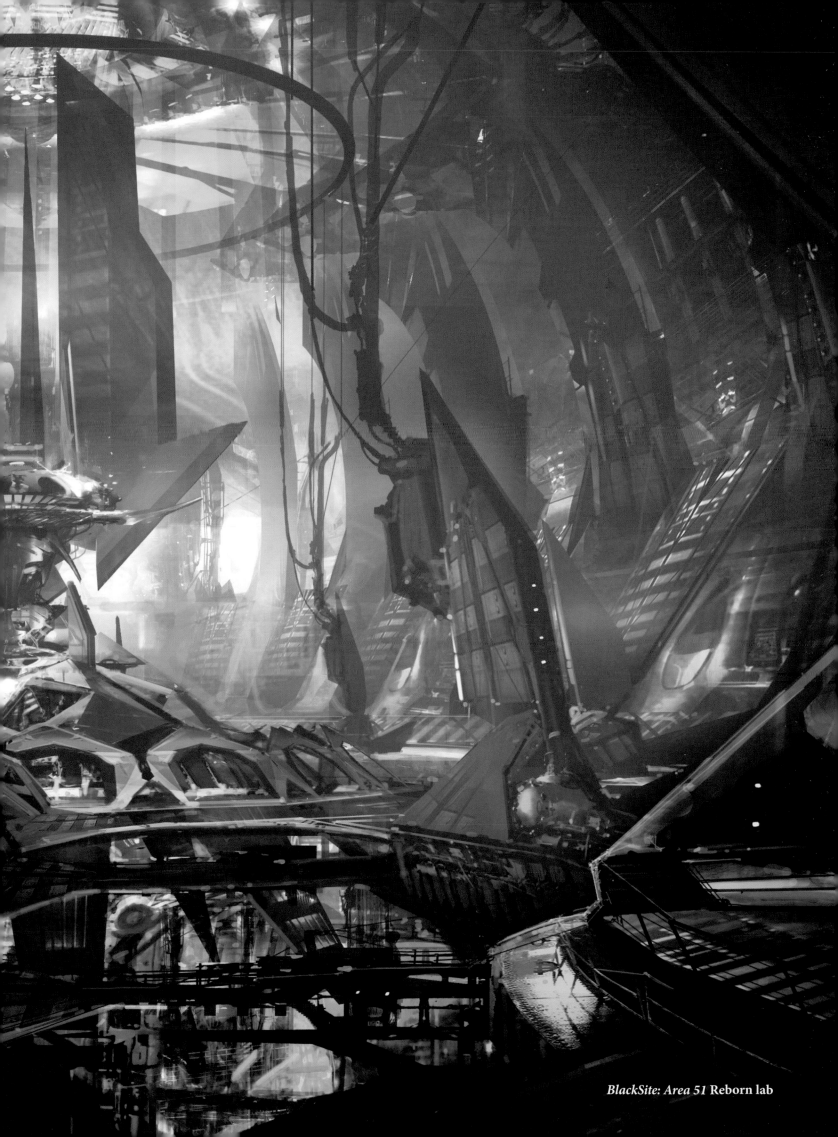

BlackSite: Area 51 Reborn lab

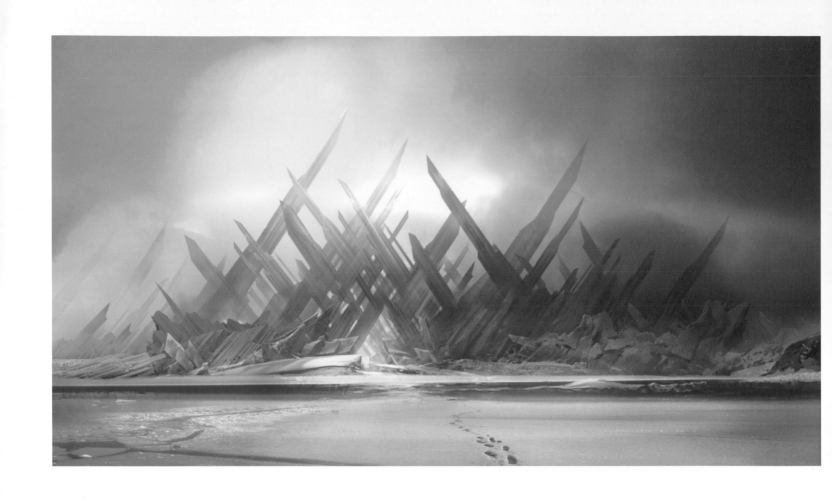

(Above) *Mortal Kombat vs. DC* Fortress of Solitude
(Below) *Mortal Kombat vs. DC* Gotham Rooftop

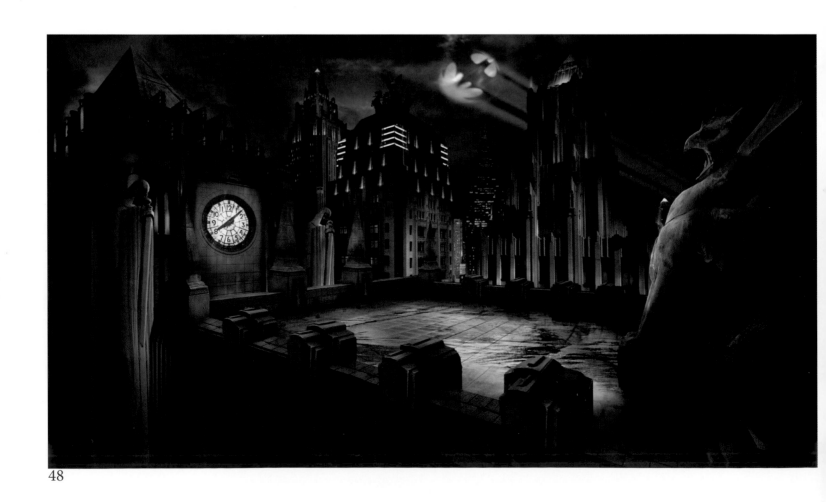

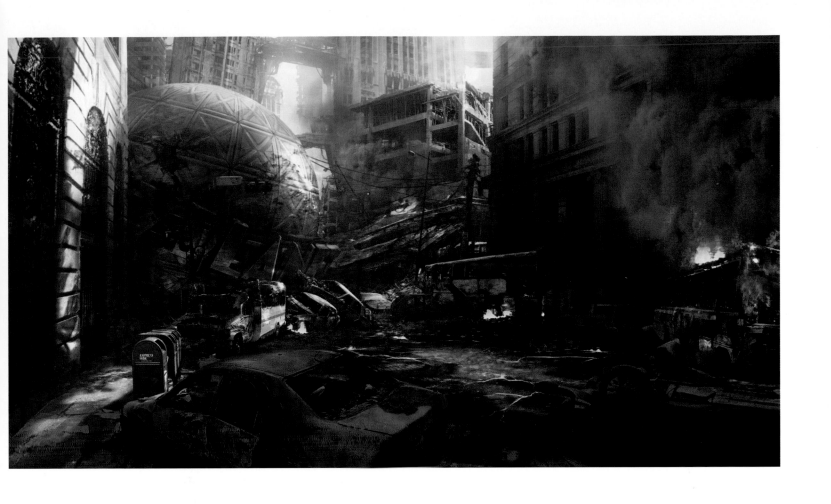

(Above) *Mortal Kombat vs. DC* Metropolis
(Below) *Mortal Kombat vs. DC* Special Forces

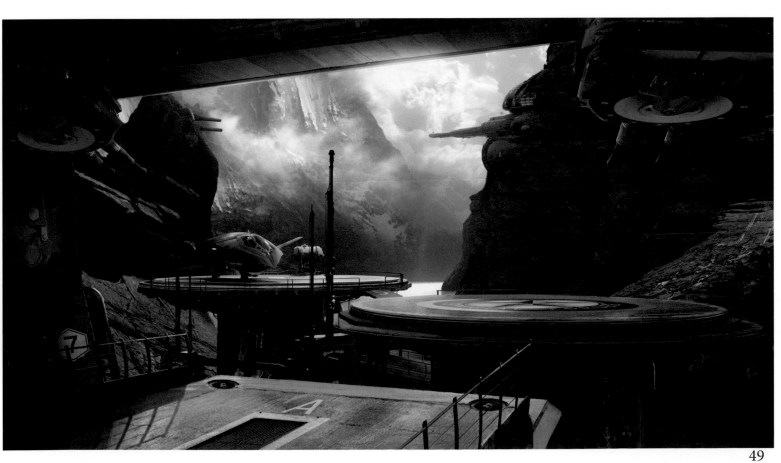

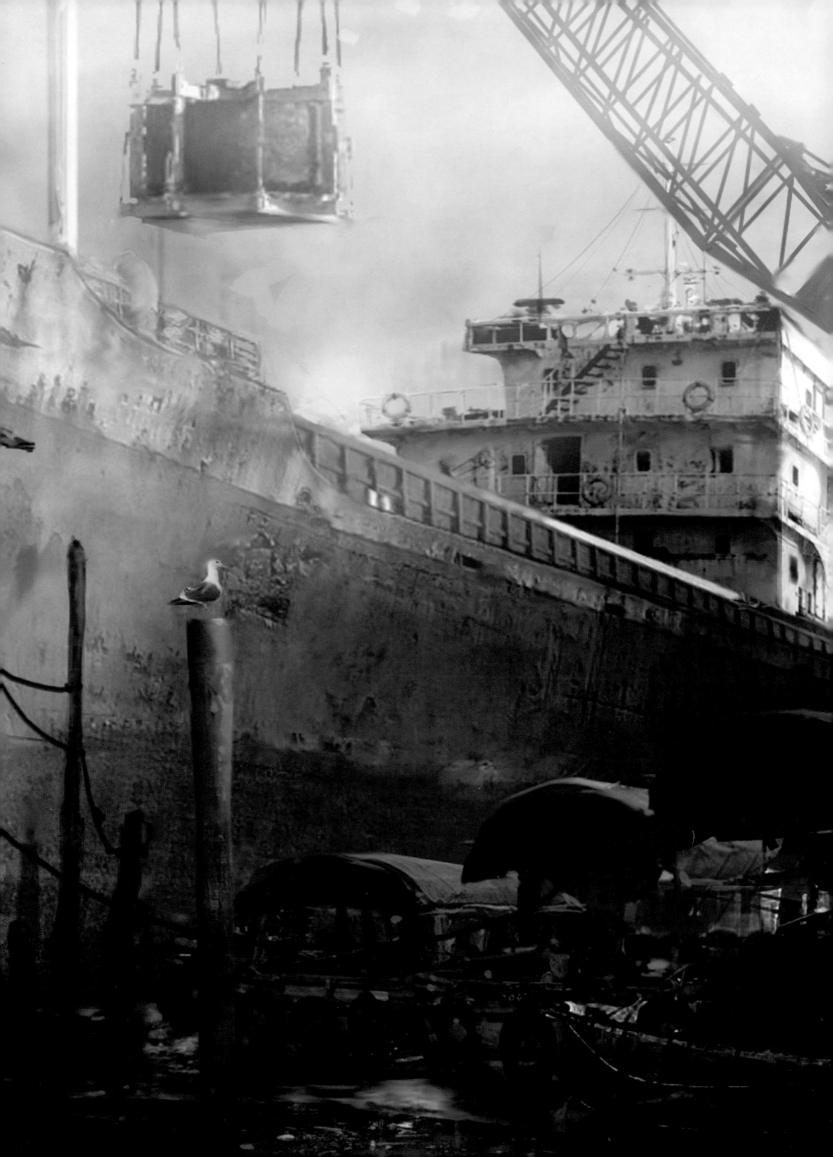

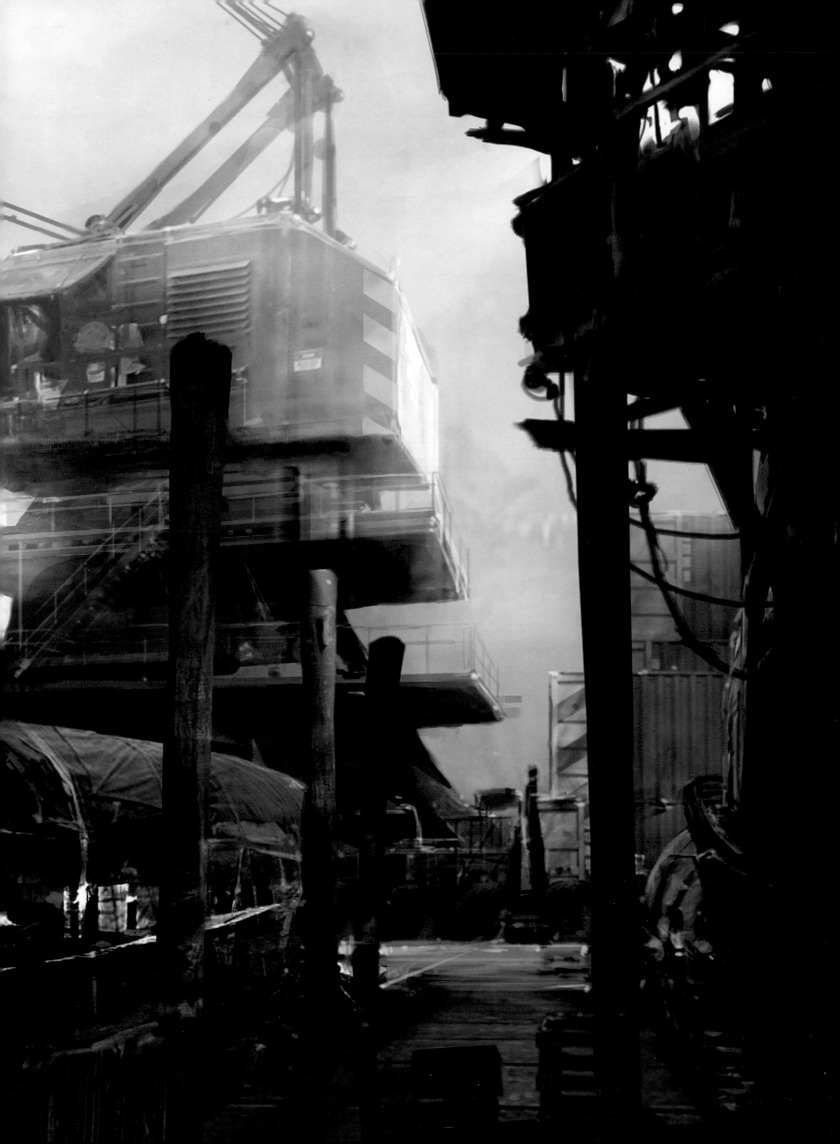

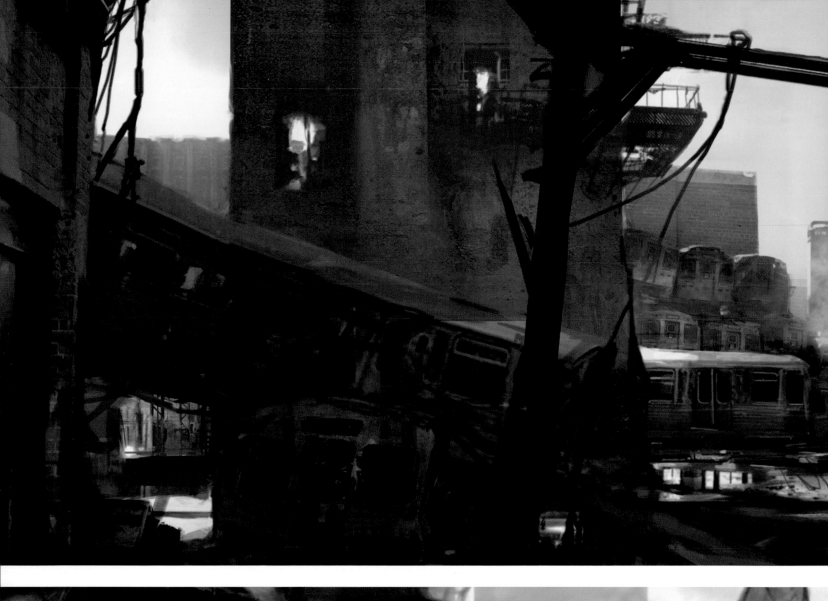

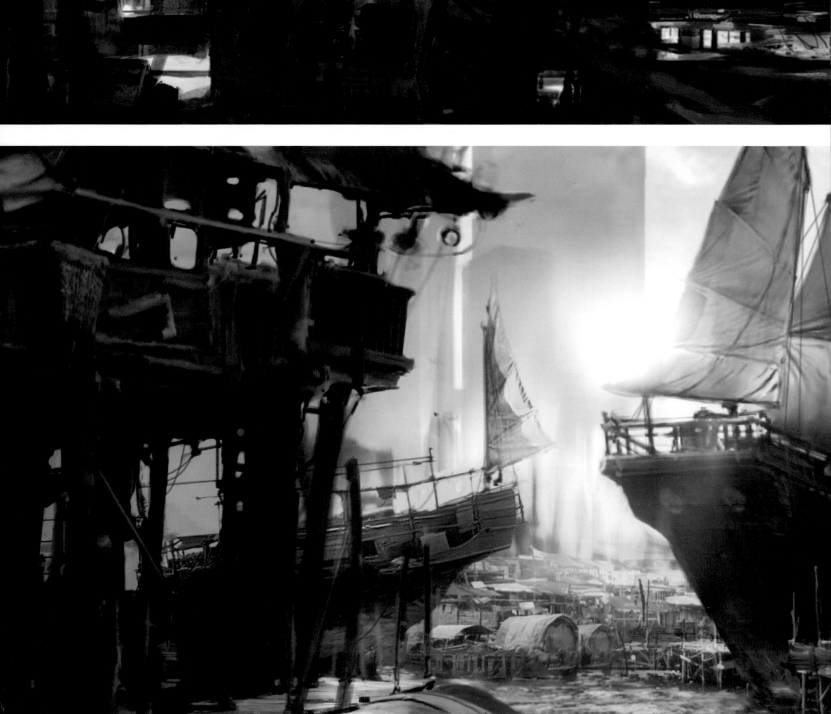

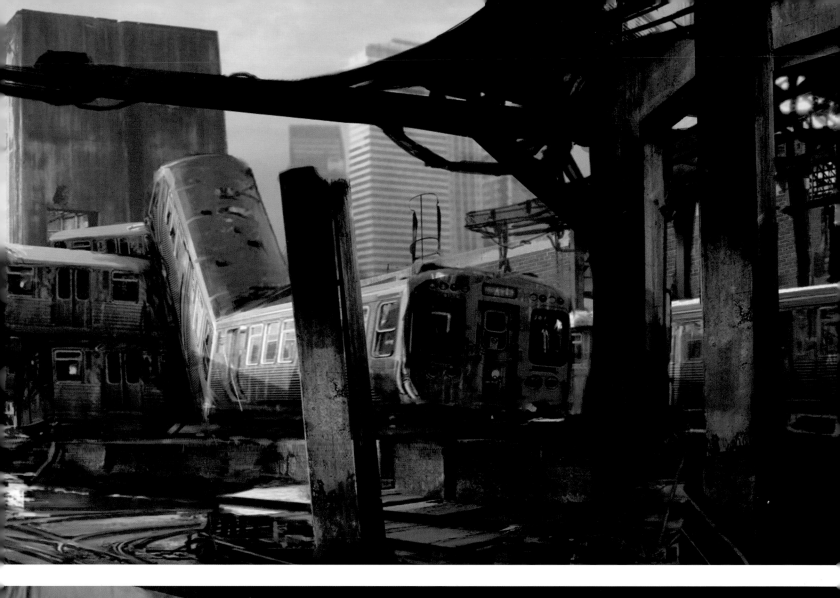

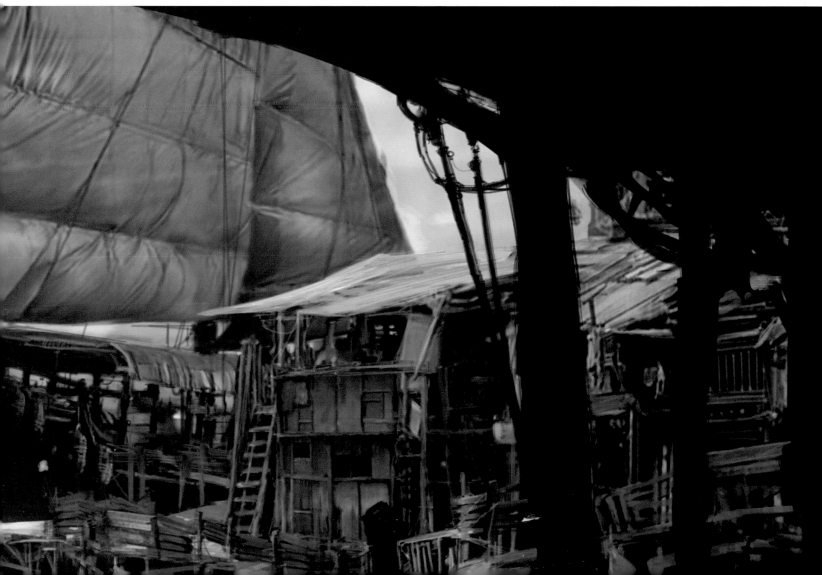

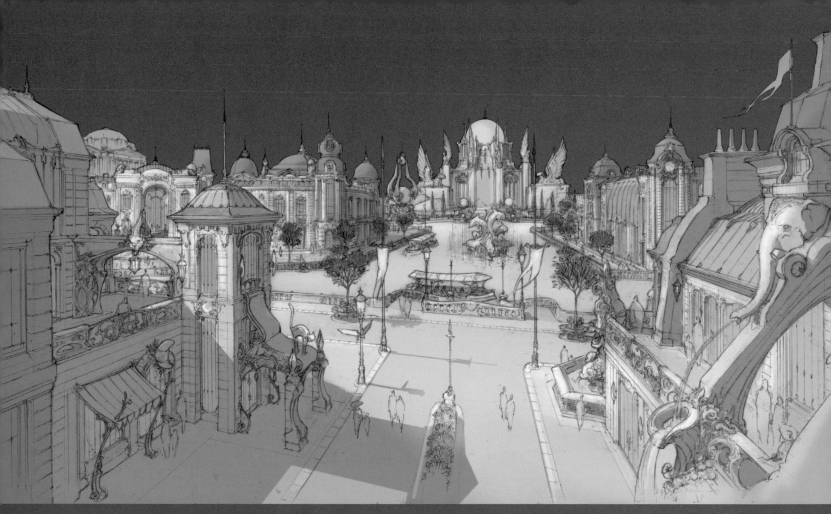

THEME PARKS & RIDES

When I first started my career I had not only a desire to be an artist and an animator; I also, more than anything, wanted to be a storyteller. This led me to become a director, which ultimately led me to doing many TV cartoon series created to promote toys. Unfortunately, what I thought was going to be a very fulfilling career ended up taking away a lot of my creative voice. So after 10 years, I wanted to find something that was more satisfying.

I was attracted to theme parks because they brought me back to being an artist and allowed me to explore my skills in both realistic and cartoony styles. After my first theme park project for Sanrio with Landmark Entertainment in Japan, I went on to do conceptual work on various Universal rides and attractions: *Toontown* for Warner Brothers, *The Race for Atlantis*, *Star Trek: The Experience*, and most recently, several attractions for the newest Disneyland in Shanghai.

Theme parks are some of the most interesting and creative projects I do, as well as being some of the most complex and challenging ones. They require an enormous amount of preparation and planning because they are actually built to scale. I continue to be awed by the fact that what I paint gets built and that people are able to experience my work as a life-sized environment.

(Above) *Dubai Project*, Paris Street

54

ABYSS RIDE

The *Abyss Ride* was a quick project that I worked on, which unfortunately never happened. It was to be a simulated ride similar to the *Star Trek: The Experience* attraction I worked on in Las Vegas This particular ride was simulating an underwater chase. The passengers in a mini submarine would duck and dive to avoid being eaten by a gigantic creature. Very often a concept can look very cool on paper, but ultimately it has to be as impressive from the audience's point of view at the scale it is intended to be (in this case several hundred feet long). The project never got that far. I would have loved to explore these creatures from the point of view of the audience seeing them, coming at them, refining the shape and working with different angles.

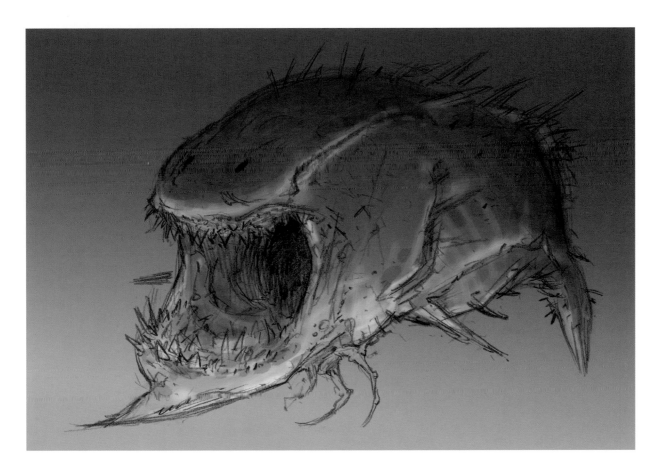

Abyss Ride creature concepts

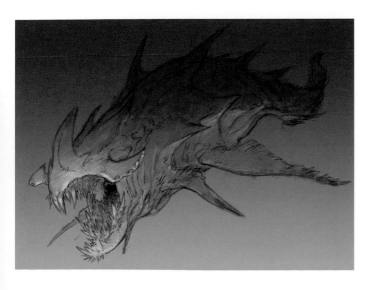

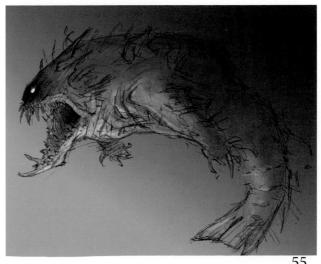

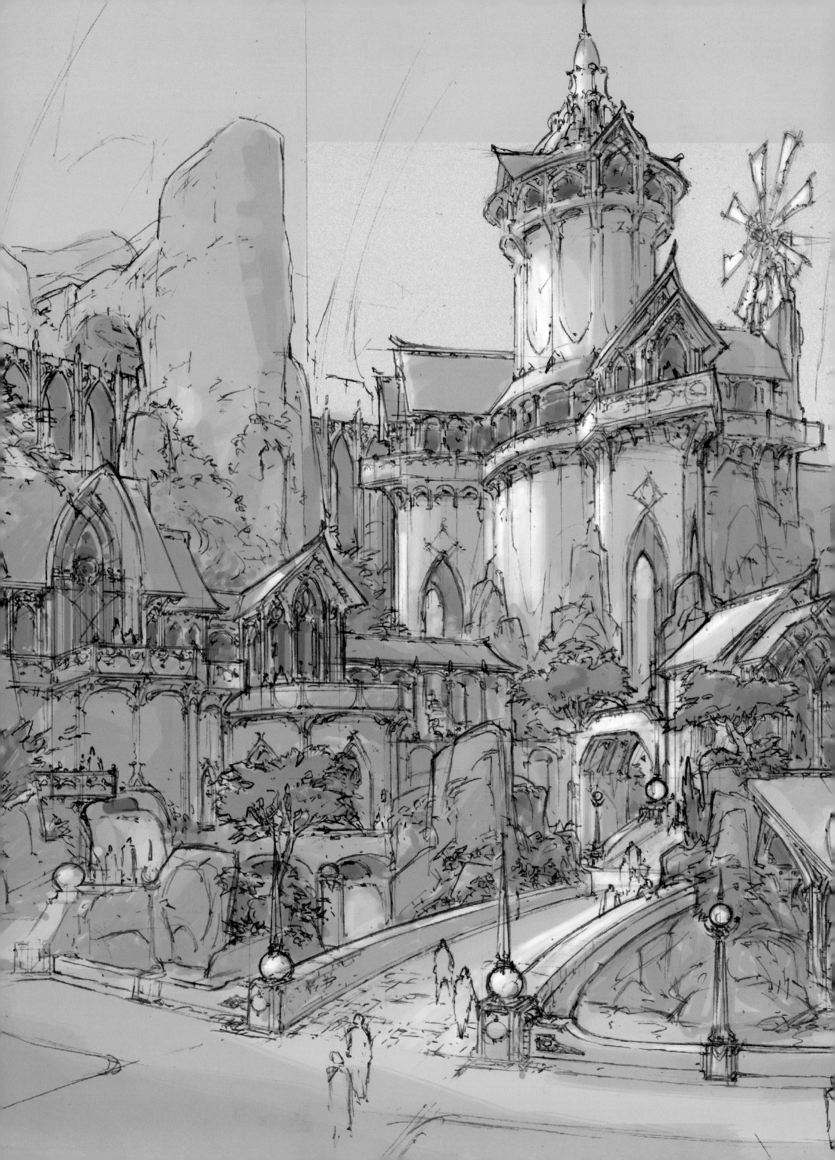

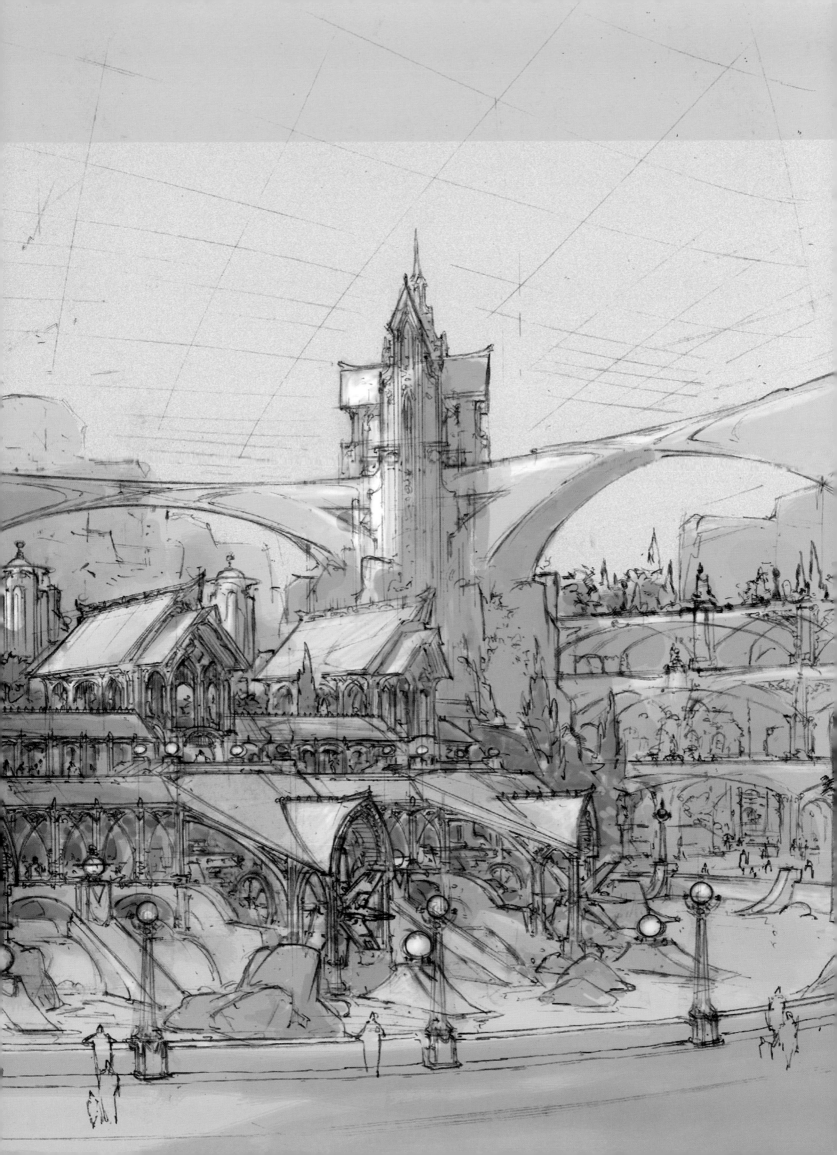

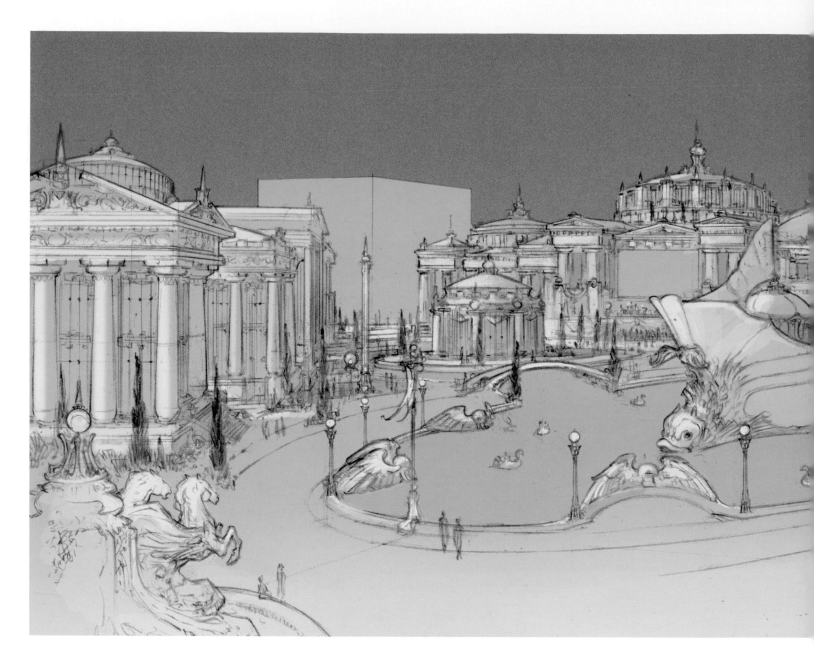

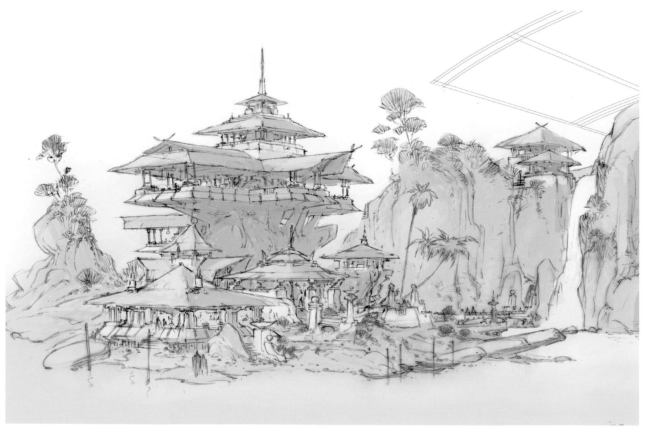

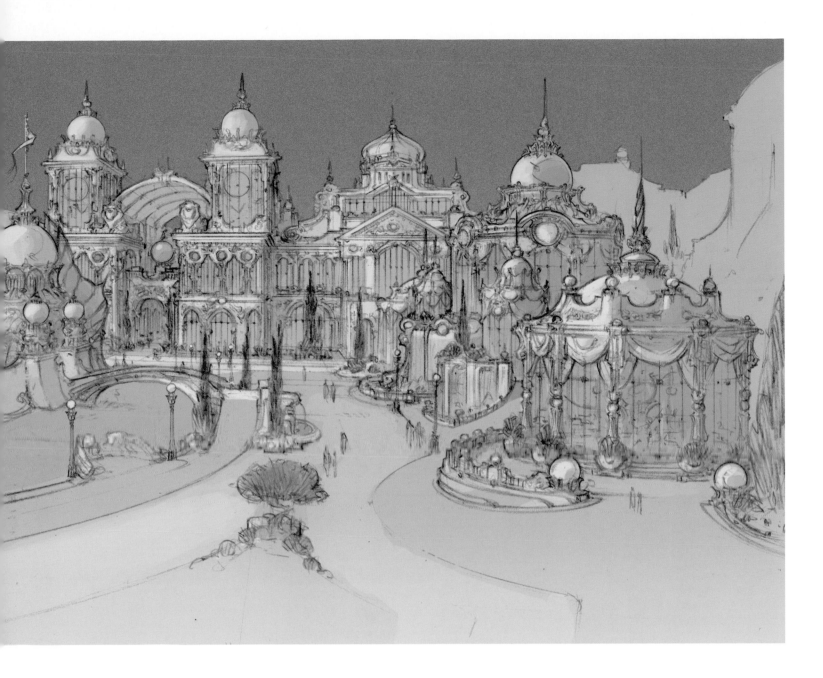

THE DUBAI PROJECT

The *Dubai Project* was one of those incredible dream projects I wish would have happened but got shut down due to financial restraints. The idea was to create a mixed theme park and retail environment that was much larger than Disneyland. It was going to represent many of the major landmarks of the world in a unique and stylized way, stretching from Paris to Egypt and so many more. I got a chance to explore my passion for architecture and fantasy, creating these magical environments based on familiar styles, with my own twist.

(Previous) *Rivendell*
(Above) *Dubai Project* Boat Plaza
(Left) *Dubai Project* Tropical Cove

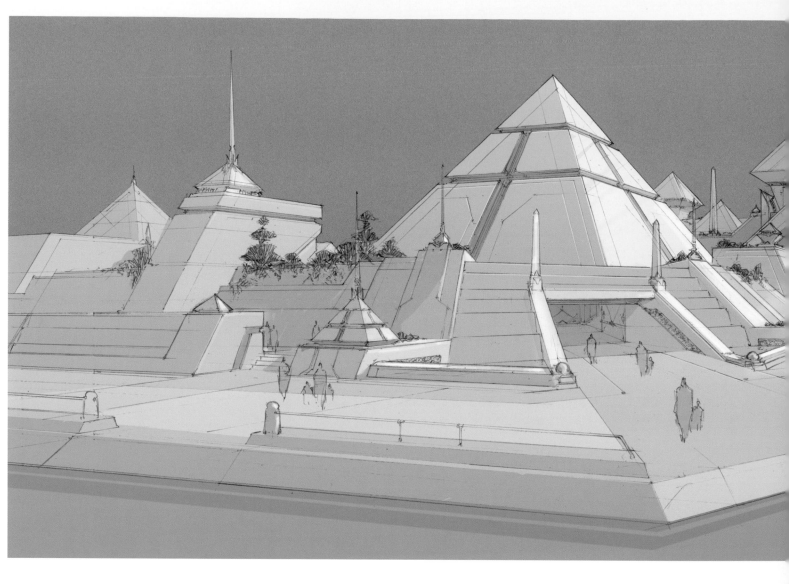

(Above) *Dubai Project* Egypt with Captain Nemo's Boat
 (Right) *Dubai Project* Asian Area

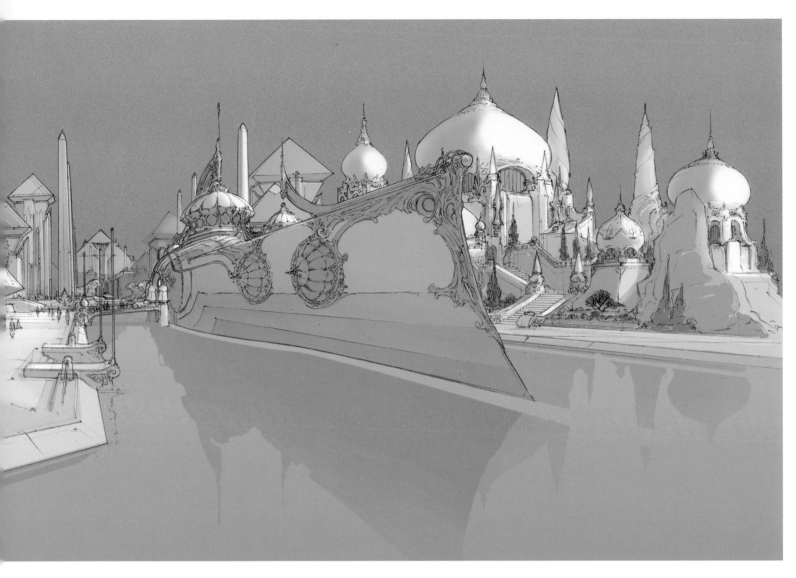

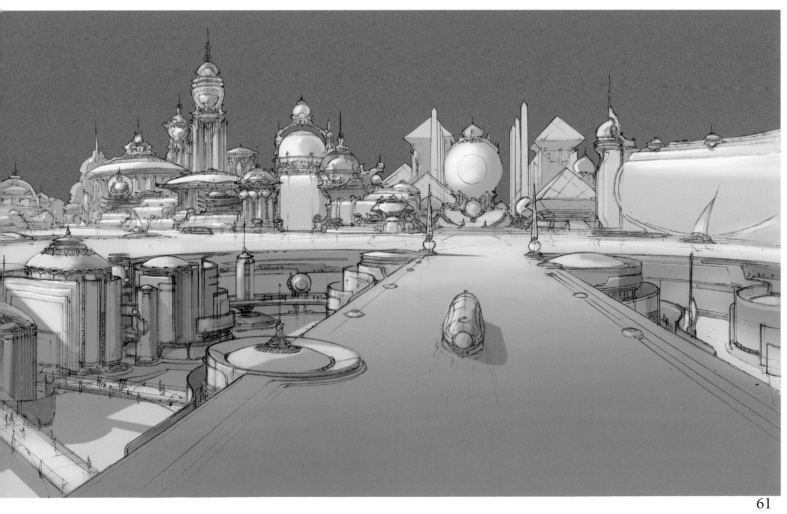

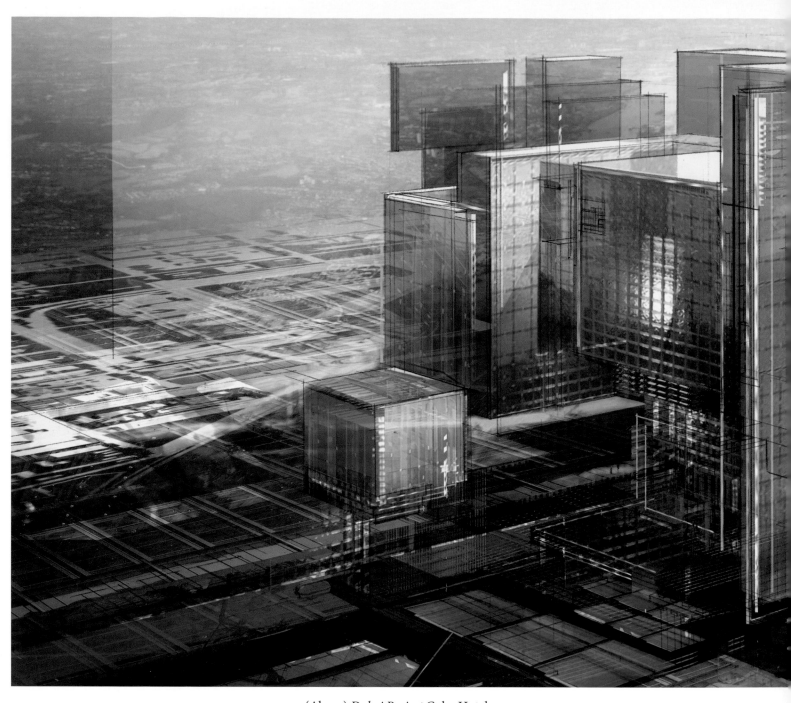

(Above) *Dubai Project* Cube Hotel
(Below) *Dubai Project* Cube Hotel Sketches

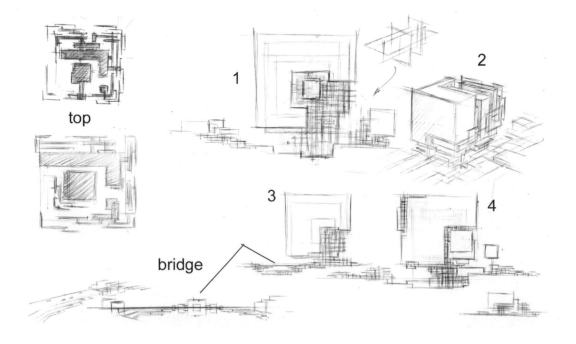

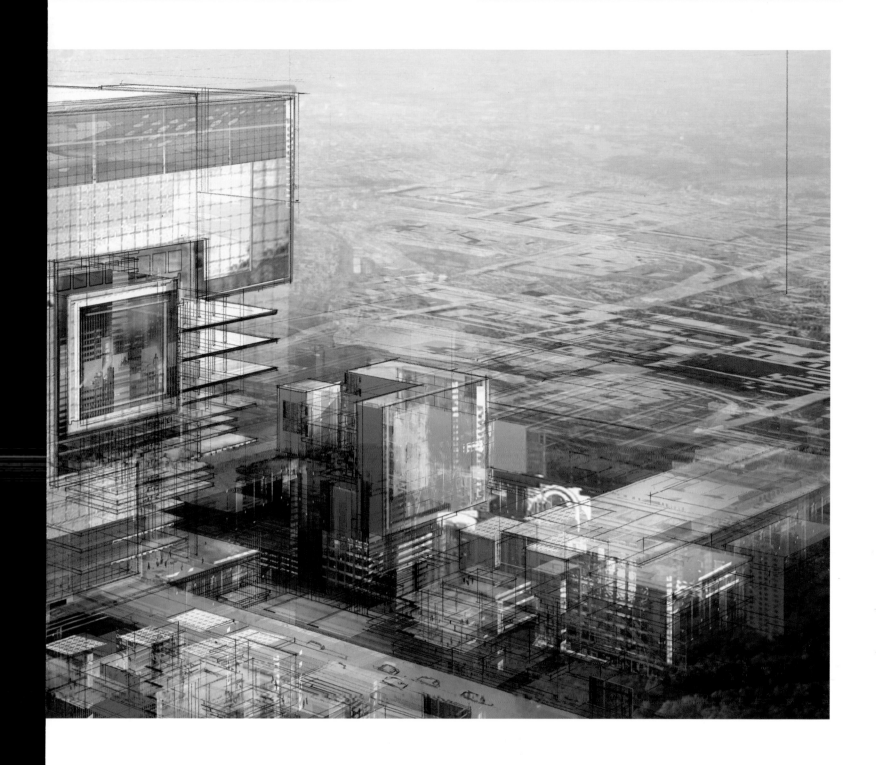

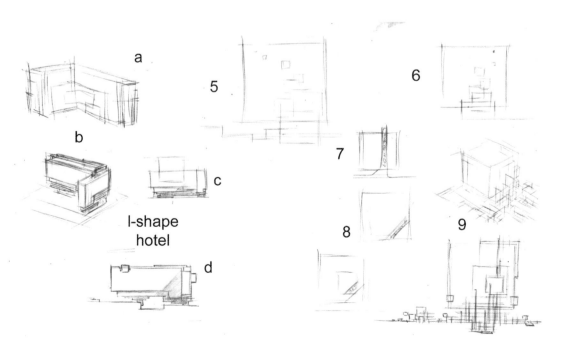

a

b

c

l-shape
hotel

d

5

6

7

8

9

Stephan Martiniere is an internationally acclaimed science fiction and fantasy artist. In the past 25 years he has become known for his talent, versatility, and imagination in entertainment fields including feature films, animation, video games, theme parks, editorial, commercial, and book covers.

His film clients include ILM, Disney, Universal, Paramount, Warner Brothers, 20th Century Fox, and DreamWorks. Stephan Martiniere has worked on movies such as the upcoming *Guardians of the Galaxy*, *300: Rise of an Empire*, *Total Recall* (2012), *Star Wars: Episodes 2-3*, *Tron: Legacy*, *Star Trek* (2009), *Knowing*, *I, Robot*, *The Fifth Element*, *Virus*, *Red Planet*, *The Astronaut's Wife*, *Sphere*, *Titan A.E*, and *The Time Machine*. Martiniere was the art director for ID Games on *Rage* (2011) and was also the visual design director responsible for the games *URU: Ages beyond Myst*, *URU: The Path of the Shell*, and *Myst 5*. He worked several years at Midway Games as visual art director for the game *Stranglehold* and later as creative visual director of the concept department for several other Midway games including *BlackSite: Area 51*, *Blitz*, *Ballers*, *Mortal Kombat vs. DC*, *Wheelman*, and more.

Other the last 10 years, Martiniere has produced over 100 book covers and numerous comic-book covers and editorial illustrations for such clients as *National Geographic*, Tor Books, Pyr, Penguin and Random House, Dark Horse, and Radical. Martiniere is currently a visual consultant and freelance concept illustrator on various films, games, and theme parks and frequently teaches workshops and presents lectures worldwide. He is an advisory board member of the CG Society.

Stephan Martiniere has received the Exposé Grand Master Award, 13 Exposé Excellence Awards, five Exposé Master Awards, two Chelsey Awards for Best Book Cover, two silver and one gold Spectrum Award for book covers and editorial, the Hugo Award for Best Professional Artist, the eNnie Award for Best Cover Art, and the Bookgasm Award for Best Cover Artist. In 2009 Martiniere was voted one of the 50 Most Inspirational Artists by *ImagineFX* magazine.

Trajectory is Martiniere's fourth art book, following *Velocity*, *Quantum Dreams*, and *Quantumscapes*.

http://www.martiniere.com
stephan@martiniere.com
@smartiniere